GAYLEN HANSEN

GAYLEN HANSEN
The Paintings of a Decade, 1975-1985

Washington State University Press
and
Museum of Art, Washington State University
Pullman, Washington
1985

This exhibition and catalogue were supported in part by: the FRIENDS of the Museum of Art at Washington State University; a grant from the Washington State Arts Commission; a WSU College of Sciences and Arts award for initiation of research projects; and contributions made to the WSU Foundation.

Printed and bound in the United States of America
Washington State University Press
Pullman, Washington

ISBN 0-87422-022-X

Cover: *Kernal in Winter Woods,* 1984 (Catalogue 31)

This exhibition is organized by the Museum of Art,
Washington State University and shown at the following venues:

Museum of Art, Washington State University
October 14-November 17, 1985

Seattle Art Museum
November 26, 1985-February 2, 1986

Museum of Art, The Pennsylvania State University
March 29-June1, 1986

Portland Center for the Visual Arts, Portland, Oregon
September 12-October 19, 1986

San Jose Museum of Art
November 15, 1986-January 11, 1987

Los Angeles Municipal Art Gallery
Cultural Affairs Department
City of Los Angeles
January 27-March 1, 1987

FOREWORD

It is with great pleasure that the Museum of Art at Washington State University presents the exhibition *Gaylen Hansen: The Paintings of a Decade, 1975 to 1985.* Not only has Gaylen Hansen been one of the most revered figures in the teaching of fine arts at this university, but his influence as an artist has been important throughout the Northwest, and in recent years, throughout the nation. It is fitting that this exhibition should be organized as a tribute by the institution that has most benefited from Hansen's presence, but it is even more fitting that we should recognize, celebrate, and make public the outstanding work that Hansen has produced these past years.

From the early seventies on, individual paintings by Hansen have been included in several national survey shows, and he has established a coterie of followers across the country. Yet opportunities to view his work in depth have been few. Apart from showing at the Monique Knowlton Gallery, his New York dealer, Hansen has had only two one-person shows outside this region and both of them have been abroad—in Canada and Germany. Our exhibition provides a much needed opportunity for an American audience to see an extensive selection of Hansen's paintings over an important period in his career. We are particularly pleased that the show will be on view at several other museums and galleries during the next two years.

Working with Gaylen Hansen on this exhibition has been a very real pleasure as well as an education. He has been at all times patient and good-humored as well as insightful and sensitive. He played a crucial role in the organization of the exhibition and has graciously contributed his thoughts and observations in the interview printed later in this catalogue. Whether braving the snow of late winter to select paintings or rifling through Hansen's shelves for biographical data, we have always been received with enthusiasm and ready hospitality by the artist and his wife, Heidi Oberheide. We are indebted to them both. Our greatest debt to Gaylen Hansen, however, is for the rich and powerful paintings he has created for the enjoyment of us all.

There are others, too, without whom this exhibition could not have happened. My colleague, Bruce Guenther, Curator of Contemporary Art at the Seattle Art Museum, selected the exhibition with me, wrote the excellent introductory essay, and was instrumental in much of the planning. His staff, namely, John Pierce, Vicki Halper, and Liz Spitzer did much of the initial organization for the catalogue and the show. At WSU we are especially indebted to the capable work of Suzanne LeBlanc, Margaret Johnson, and Pamela Lee from the Museum of Art, Marjorie Becker of the Fine Arts Department, and to Managing Editor Fred C. Bohm and Designer Christine Mercer from the University Press. A further key figure in the preparation of the exhibition has been Monique Knowlton, Hansen's dealer in New York, and her Director Linda Marchisotto, both of whom have been invaluable throughout this project.

Much-appreciated financial support for this exhibition and accompanying catalogue has come from the ever-reliable FRIENDS of the Museum of Art at WSU, from the WSU Foundation, and through a grant from the Washington State Art Commission's Partnership Program.

Finally, we would like to extend a special note of gratitude to those individuals, museums, and corpora-

tions who have generously made works from their collections available for this exhibition. Without their willingness to part with their paintings for a lengthy time and to share them with a wider public, this exhibition could not have taken place.

Patricia Grieve Watkinson, Director

INTRODUCTION
by Bruce Guenther

On his way out to the studio one afternoon Gaylen Hansen was stopped short by the sight of two large dog heads looming out of the tall summer grass of a neighbor's yard. Silhouetted against the rolling hills of the eastern Washington landscape, the sleeping dogs assumed a disembodied, monumental presence he found transfixing. Hansen did not forget those dogs; in fact, they reappear in the painting of the last ten years as some of the most evocative, and at times disturbing, images of his career. Hansen possesses the imaginative gift to transmute an everyday event into a vividly animated vision. His rural fictions create a universe slightly askew and suffused with gentle wit.

For Gaylen Hansen, everyday events are rooted in his experience of the land, the sky, and the seasons. Born in Garland, Utah, he grew up on a farm in the path of one of the western flyways of migratory birds. Hansen experienced the cycle of seasons on the farm and observed the great migrations of birds of all description that would fill the sky overhead. Pursuing his early talent for drawing by studying art in Utah and California during World War II, he received his Master of Fine Arts from the University of California, Los Angeles, in 1953. Hansen's work following school and throughout the fifties was grounded in Abstract Expressionist aesthetics. Basing his paintings on actual landscapes, he developed loose, intuitive abstractions with a rich, somber palette.

Hansen moved to eastern Washington in 1957 to accept a teaching position at Washington State University, a position he held until his early retirement in 1982. A popular and influential teacher, he experimented with various art movements to absorb the lessons they had to offer, and to keep his students in touch with the world beyond eastern Washington. The iconization of the mundane in Pop Art, the spatial lessons of Op Art, the elevation of phenomenological experience and real space in Minimalism—each was assimilated by Hansen into his increasingly eccentric and personal vision. During the late sixties Hansen adopted a more linear, less gestural working method, and his paintings became more anecdotal. Many of the stylized images he introduced at this time—cropdusting planes, fish, and animals—appear in his work today.

While Gaylen Hansen had come to terms with the isolation of eastern Washington early on, it was not until the mid-seventies that he acknowledged his work would never play a prominent role in the national contemporary art arena. This realization freed him to pursue a highly personal course, without regard to fashion or marketplace, and to paint those things in the world around him that gave him pleasure. The irony was that, in shifting away from the mainstream, Hansen created a body of work that attracted national attention and acclaim.

Central to Hansen's paintings of the last ten years has been a character known as "the Kernal," a western Everyman whose uncanny resemblance to Hansen himself is more than accidental. The cowboy hat and boots, the corncob pipe, and whiskers jutting out from his chin are as much features of Hansen as they are of the Kernal. The Kernal is Hansen's alter ego, the protagonist for his tall tales of the High Palouse countryside of eastern Washington. He is the embodiment of the Old West mystique, an outdoorsman whose exploits in the wilds are filled with animals of gigantic proportion and wildly improbable twists of fate—which inevitably resolve themselves

happily. Through the Kernal, Hansen, an inveterate storyteller, melds nature, anecdote, and disparate formal sources—art history, folk art, popular culture—to create a mythology of place.

The artist sets his highly subjective observations of daily rural life against a landscape that is specific in topography and imagery. Just as Marsden Hartley's late works are identified with Maine and Grant Wood's are tied to the Midwest, Hansen's work is inextricably joined to the Palouse country of eastern Washington. The Palouse is a sparsely populated, high plateau of rolling hills, a countryside of extreme lights and darks under a 180-degree sky. It is dryland, wheat country where the hills are sculpted by the wind and patterned by the tracks of plows furrowing the soil. This is a landscape without scale, in which the occasional tree or solitary farmhouse only emphasizes the spatial disorientation one experiences traveling along the empty country roads. Subject to extremes of heat and cold, wet and dry, the landscape metamorphoses with the seasons—the snow of winter turning to the dark, wet earth and bright green of spring, the full summer wheat fields giving way to the brown earth and straw of fall. The topography in Hansen's paintings, though general and abstract, mirrors the experience of this landscape, responding to the dramatic seasonal shifts of light and color.

Against this landscape, Hansen disports a cast of characters—the ubiquitous cropduster, grasshoppers, wolf-dogs, and trout—who are integral to the experience of the place. Like the Kernal, these players in the narrative of the paintings are icons that convey the essential qualities or gestures of their real-life equivalents.

Codified, symbolically dressed men and bare-breasted women pass across the canvases of the mid-seventies engaged in some little known rural ritual—

in a landscape alive with stylish magpies, dancing flowers, curious wolf-dogs, and mythically proportioned trout. Arranged low in the foreground of the shallow pictorial space, the figures in silhouette take on a frieze-like quality that calls to mind Egyptian or Assyrian antecedents, as well as American folk art. Each figure occupies its place in the composition with a cool detachment that gives the paintings of this period the distinct feel of a still life or traditional decorative architectural panel. Ritual players in an allegorical encounter, women in long skirts receive the attentions of men in buffalo masks, Indian chiefs, or the Kernal himself proffering a man-sized rainbow trout.

As the paintings have evolved, the figures have become less stiff and more three-dimensional, and their activities have taken on greater emotional or psychological implications. The canvases of the eighties are dominated by the Kernal with few, if any, other human characters taking part in his exploits. While certainly reflecting changes in Hansen's personal life—a divorce and his retirement from teaching—the emergence of the Kernal as the central player also heralds the increasing importance of narrative action in the paintings. Gone is the sense of ritual processional or pastoral meditation; now the Kernal is always in the throes of some wild adventure among animals of dreamlike proportion. A relentless storyteller, Hansen has incorporated folk tales and his own sly twists on reality into the weft of his recent work. Just as storytellers' yarns teach us to see beyond the single point of view and help us to understand the multiplicity of the world, Hansen's tall tales offer a new perception of the present. Devoid of urban anxiety and violence, the episodic action catches us off guard with its exuberance and often eerie psychological tension. The incidents in Hansen's paintings

are gentle, improbable fables fraught both with the tongue-in-cheek humor of the sky raining fish and the anxiety of man-sized grasshoppers swarming around the Kernal on horseback.

Structurally, Hansen's paintings are a sophisticated synthesis of skillful design and unique imagery, an integration of form and content. Beginning with a loose drawing on unstretched canvas, Hansen develops a composition with strong directional axis. The placement of objects seems at once casual and absolutely correct, even inevitable. Using line and a color border to contain the activity of the imagery and emphasize the flatness of the canvas, he plays movement and the negative spaces around the figures against the frame. Hansen's paintings are worked very carefully using thin underpainting slowly to build up the complex color relationships and integrity of the paint surface. The plants, animals, and landscape have gone through a generalization of form that makes them more universal and at the same time reveals the influences Hansen has absorbed. Early figures recall Egyptian tomb paintings in their standardized profiles and colors, while more recent works speak of Hansen's long-time admiration of Henri Rousseau's *The Sleeping Gypsy*.

Gaylen Hansen's intimate fictions combine the imagined purity of a child's vision with complex psychological insights. He creates a world in which the antics of giant tulips and anthropomorphic dogs take on monumental importance. With warm wit and humor, the artist manipulates the familiar to challenge our tidy preconceptions of what is and is not true. In Hansen's world there is no established hierarchy of dominance; plant, animal, and mankind share equally in this vision, bringing to mind a contemporary peaceable kingdom. There is something ultimately reasonable about the world depicted in Hansen's paintings. Within the free exchange between fantasy and reality, memory and the present, Hansen conveys unsentimental emotion and an innocent's vision of a world that could be.

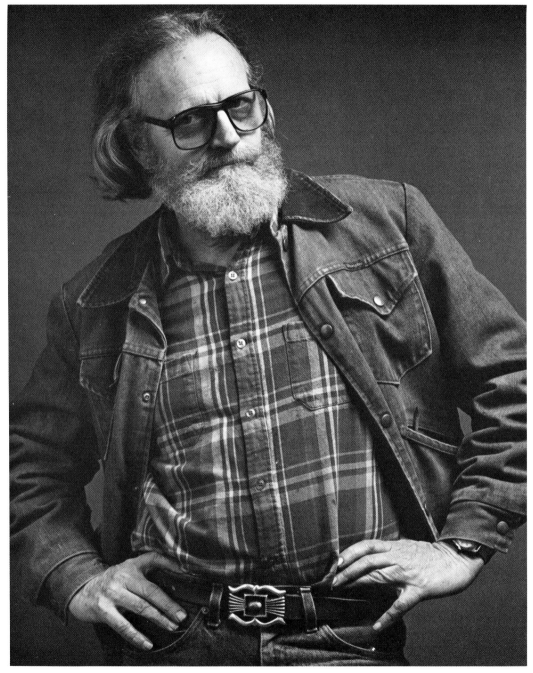

Gaylen Hansen
Photograph by Marsha Burns, ©1982

AN INTERVIEW
by Patricia Grieve Watkinson

This interview with Gaylen Hansen took place in late February, 1985, at his home in the small, country town of Palouse, Washington. The town shares its name with the surrounding Palouse region, a geographically unique landscape that has figured as the general and unostentatious background in Hansen's paintings over the past decade. Hansen lives at the edge of town with his wife, the painter Heidi Oberheide, in a small frame house flanked on each adjoining lot by their respective studios. Oberheide's is newly built; Hansen's is the neighboring, matching frame house, now partly gutted to provide sufficient wall space to staple up his large canvases. At the time of this interview, paths beaten through the snow led the fifty or so yards from the front door to each of their respective studios. A few feet behind these buildings, the land falls away to a small valley between the wheat fields where the North Fork of the Palouse River winds through cliffs dotted with pine and hawthorn, the backdrop against which many of the protagonists of Hansen's work—the magpies, ducks, dogs, cats, horses, and cropdusting planes—go about their real-life activities.

Hansen spoke at length about many aspects of his career as a painter: his teenage years in the forties when he painted the first abstract works to music; his exposure to the New York art world as a student; the long years as a university professor of fine art and the frustration of teaching art and fostering creativity within the confines of a university structure; his amusement at those reviewers who have considered him a genuinely unsophisticated or primitive artist;

and the changes that the recent recognition by the art world have brought. Hansen's words provide valuable insights into his ways of thinking. And the manner of his response, his tone and attitude, reveal something still further about the somewhat enigmatic character of the artist and his art.

Hansen is, for example, a born story-teller. He is a master of the slow, controlled delivery that, in the best of traditions, intersperses elements of the dramatic and the serious with turns of wit and fantasy. It came as little surprise, therefore, that when Hansen decided to allow himself free reign in his work rather than follow art world dictates, his painting should have taken a narrative bent. Central to many of his narratives is the figure of the Kernal who experiences situations that range from the mundane through the improbable to the fantastic: at one moment the Kernal sits peaceably by a camp fire, the next he is seen riding between dog heads the size of small hills. Hansen extends his narrative to other creatures: wolf-like dogs meet nose to nose with extra-large grasshoppers or suffer attack by aggressive magpies. It is not as if these scenes are only absurd, for some such chance encounters can and do occur; it is rather that they are presented in so deadpan a manner that we do not know what to make of them. They are indeed as deadpan as Hansen himself. Are these welcome or threatening encounters? The artist gives little help through his paintings or his words, and, with tongue typically in cheek, appears to relish the enigma of the situations he has created and the playful perversity to which he subjects viewer, protagonist, and self. It is clearly the "willing suspension of disbelief" that enables Hansen to paint a dog taking a bite out of the moon or a floating fish filling the sky. His work convinces the viewer that such occurrences are possible, even natural, not by means of

trickery or device, but because Hansen has suspended his own disbelief during the process of creation.

A dog split from head to toe or a herd of buffalo charging headlong to a precipice—Gaylen Hansen's proclivity for high drama, boldly depicted, is clear from his paintings and from his own words. Through all this runs a spry, yet kindly, sense of humor that never quite rests. It reveals itself in the offhand comment or in the small touches of wit or the visual puns that enliven his paintings: in *Kernal Lying Down,* smoke from the character's pipe echoes the fire of a distant, erupting volcano, while in *Fish in a Landscape,* the wing tip of a passing magpie appears from behind the crest of a hill, like a shark's fin.

The autobiographical aspect of Hansen's work, although discounted by the artist as being merely the raw material from which he draws his sources, is nevertheless readily apparent. Hansen's comments in the interview leave no doubt of its significance. Not only is the Kernal the spitting image of Hansen, but the fictional cowboy's recurrent occupations of trout-fishing and camping are also favorites of the artist, who, one surmises, might relish taking part in some of the Kernal's more adventurous activities. Moreover, a work such as *Kernal at the Presentation,* painted after Hansen had traveled to New York to receive the New Museum's Sambuca Romana Prize at a formal reception, is clearly directly autobiographical and reflective of Hansen's feelings toward the experience. Other paintings from the past decade are likewise peopled by identifiable characters from among the artist's family, friends, and colleagues and relate to specific events or suggest emotions associated with various periods of the artist's life. Indeed in conversation Hansen refers back, with seemingly effortless recall, to incidents and episodes throughout his long career. Sometimes the stories about himself and his development as an artist are told so smoothly that one cannot but conclude they have been repeated frequently to students, to friends, and just a little embellished for each listener. But more important than that, Hansen's self-awareness of his own growth as an artist and his constant reassessment of his purpose and philosophy discount any suggestion that his approach is either unselfconscious, primitive, or naive—all of which have been suggested. This self-referential aspect is seen in the paintings too, which, even while breaking new ground, can refer back to earlier themes. So in *Birds with Pink Torso* of 1984, the Egyptian-style woman/bird is a recurrence of an image most frequently found in the early seventies and the treatment of her lower leg clearly recalls the Bent Leg emblem that Hansen devised in the sixties and even used as his signature for some years.

However, the references in Gaylen Hansen's work and conversation are not circumscribed by his own life, surroundings, or art, but embrace the broad sweep of art history. Giorgio Morandi, John Cage, Le Douannier Rousseau, Phillip Guston, Piet Mondrian, and Willem de Kooning are some of the artists who have been influential in forming his philosophy. To some of them, notably Rousseau, Hansen owes a direct debt. Aware of the artistic context in which he is working and well-informed about developments in the art world in general, Hansen is intellectually absorbed by many things. One is a curiosity about the creative process itself and a concern with analyzing the mind of the artist at work. It is this readiness to question and to experiment that has, in part, placed Hansen in high regard among his students and colleagues. Another of Hansen's absorbing concerns is a rigorous approach to structure and form in his

paintings and an emphasis on placement. It is through the arrangement and placement of forms that the artist brings about the strength and yet basic economy of his painting. The simplicity of his work, which has proved deceptive to some, has been consciously sought and achieved. It results from a reduction of all possibilities, much in the manner of abstraction or minimalism. It is also an essence extracted from the experience and knowledge accrued by Hansen over the years. It is simplicity born of wisdom, and not of naivety.

Gaylen Hansen is an artist committed not only to the intellectual processes of making art, but to the physicality of the paint medium itself and its capacity to communicate. A close observation of his painting reveals a delight in the tactile elements of paint, its brushstrokes, surface, gesture, handling, and color. The richness of his painting, the fluidity of his washes, and the capturing of subtle light effects combine in an almost poetic fashion. What neither the paintings nor the following conversation reveals, however, is the single-minded discipline with which Hansen pursues the activity of painting. Rising early, working long hours in his studio, with often more than one painting in progress at a time, he has been particularly prolific in recent years. Yet he remains highly critical of his works, musing openly on their strengths and failings, sometimes finding hidden pleasures such as an unexpected quality of light, and finally after a decent period of time ruthlessly destroying those that do not hold up to his standards—usually by burning them in the yard.

Patricia Watkinson: Gaylen, the earliest work of yours in this exhibition, *Kernal on Horseback,* is from 1975. Let's talk about why we decided to start at that point.

Gaylen Hansen: Well, there was a definite change in my work around 1975. It probably had to do with a sabbatical leave coming up about that time. They used to come as often as the locusts—every seven years. I was sitting in the studio and it occurred to me that I was about as anonymous an artist as anybody could get without having disappeared completely into oblivion. And that I had about twelve years to go before retirement from teaching. It was a nice spring day, the chickens were out in the yard, the plum trees were in blossom. I could see the dog out there and magpies, ducks, things of that sort. It also occurred to me that at this late stage I probably wasn't going to connect much with modern art or New York or any kind of mainstream developments, so I might as well do what amused me primarily.

Prior to that I had been concerned about the rest of the art world. In my role as teacher I had felt I needed to know what was going on, besides, I was usually excited about all the new movements and took a stab at them as they came along.

Anyway, that day I tacked a large piece of canvas directly onto my studio wall. I hadn't done that before. I had the feeling that this way I would paint less self-consciously. I sort of fooled myself into thinking I wasn't really doing a painting, or doing art, but that I was just putting some interesting images on the wall. It sounds trivial, but it seemed to be very significant.

The first work I did in this spirit was an Egyptian-like painting of three women with chickens on their heads and a couple of Bent Leg cannons. Mind you, the imagery wasn't new. The women had already appeared in drawings and the cannon came from my Fort Bent Leg period. No, what was new was this method of working. It really loosened up my approach.

PW: What *was* "Fort Bent Leg?"

GH: Well, from around 1964 my work was somewhat associated with the early days of

the West. Fort Bent Leg was a place where anything could happen. It started with a drawing of a single bent leg. Some people refer to them as socks, but I like to think of them as legs, bent legs. I did the drawing early one morning, and it appealed to me because it didn't make any sense. It was absolutely trivial. I think my reaction had something to do with being an art teacher in a university art department where there's supposed to be a rationale for everything. At any rate, the Bent Leg gave rise to a whole series of inventions, including a series of Bent Leg sunsets. It was kind of a funky approach.

PW: But your imagery then changed from this funky subject matter to one rooted more in your immediate environment. It began to include things from your domestic surroundings—dogs, chickens, tulips, etc.—as well as from the landscape of eastern Washington, especially the region known as the "Palouse." You adopted features of the countryside, of nature, and you incorporated local fauna, if not flora—magpies, grasshoppers, ducks, trout—as well as more exotic animals such as bear, bison, and eagles. I don't want to imply that your approach was in any way documentary, but there was definitely a new sense of place in your work. The only remnant of the Fort Bent Leg period seems to be Kernal Bent Leg himself . . . or yourself

GH: Part of the reason I paint subjects that are around me in the Palouse is simply because they're around me in the Palouse. However, I don't think I'm a regionalist in the sense that, "Well, here's a place, I'm going to express it." There's not conscious intention to put the Palouse on the map in that way. I'm not doing a piece of Americana. I don't think so. I hope not. But at the same time there is something to be said for identifying with the environment you're in. I don't think that's very new in art. The International Style and principles associated with non-objective art led one to believe that one's immediate environment wasn't very important and that the art done in one place should be about the same as that done in another. I don't buy that idea . . . obviously. I like to

think that a good painting does have a sense of place.

PW: That also seems true for the sense of the time of year, of the seasons, in your work.

GH: Yes, I do seem to be affected by the seasons. Right now the snow is piled up around us and as you can see I have been doing several high-key snow paintings. All of them are of the Kernal sitting or standing by a campfire in the dead of winter. In the summertime I usually do a few warm-colored, earthy paintings. And last spring I did several green paintings. One of them is the green *Dog Heads and Swimming Fish* and another, *Snake River Dogs,* which was inspired by a drive along the Snake River in Idaho in early April. Of course, since they dammed it up it's not a river anymore, but the "breaks" are as awesome as ever. Nature is a pretty good artist. I like the way she changes the landscape from brown to green to white.

PW: So your use of color is related to, if not suggested by, the time of year, the immediate environment, the countryside

GH: Right. I really don't use color realistically as a rule, nor do I want to duplicate the color out there in the Palouse, in nature. In my paintings color becomes structured in a way that relates to medium and to content. I often go for understatement, for restraint in color. Although, when I had my show at the Glenbow Museum in Calgary in 1982, the light was especially nice on the paintings, and I was rather surprised to find that my color looked . . . yummy!

PW: One of the things that becomes apparent as we talk is your awareness of nature, of the rural landscape in which you live. I don't believe one would necessarily deduce this interest from your work itself, which I know is how you would want it to be. Just now you spoke of deciding in 1975 to paint what "amused you primarily," and it seems to me that what amused you had to do, at least partly, with being a country person, and growing up on a farm with horses, cattle, sheep and all the barnyard paraphernalia.

GH: Yes, I'm definitely a country person. I have lived in cities from time to time, but I'm much more at home in the country. When you grow up with your feet in the dirt, it makes a difference to the way you relate to nature. I suspect some of my paintings get a bit overly sentimental. You have to watch it when you're painting animals and fish, so you don't go overboard. But that's a chance I've been willing to take.

PW: Sentimental? Perhaps in a painting like *Wolf Dogs* where three dogs huddle together under the onslaught of two magpies, there is a certain appeal in the characterization of the animals. You have captured what appears to be the essence of dog-like behavior. But it's not sentimental in a pejorative sense. It's not saccharine. In fact it makes me think of Native American art where animals are seen as possessors of spirits with messages to communicate and roles to play.

GH: In that painting I wanted to suggest the wildness of the dogs—they're really more like wolves. I also thought the way they related to each other, the way they touched, was something that humans could identify with. At least I identified with it. I find that creatures like dogs are wonderful to look at. In a way they're more intense and more visually attractive than we humans. They don't need clothes, jewelry, and body paint. Then I suppose advanced humans are more separated from animals than earlier peoples were. It's "us" and "them" these days. It still is to some extent with me, but I think I break through that sometimes and feel that it's "us," and not "us" and "them"!

It's kind of corny, having animals behave like humans or relate to humans. But I get a kick out of it. So I do it. It's something that you find in fairy stories. The animals I paint behave somewhat like characters in a fable. Sometimes I do indeed anthropomorphize them. Also, I know them pretty well—most of the animals I paint are part of my immediate yard. Although even some animals and insects I know well wouldn't be very paintable to me. Some insects especially

I couldn't identify with. I especially like grasshoppers because they're so paintable.

PW: How so, paintable?

GH: They have a very simple shape and they're not too intricate, so they are relatively easy to paint. Plus every summer there's the threat of being overrun by grasshoppers. I suppose some insects you feel well disposed toward and others you cannot. The same with animals or fish. I really prefer trout. Then I am a trout fisherman

PW: While we are talking about your imagery, there's one major aspect we haven't touched on—Kernal Bent Leg himself. He appears in many of your paintings, riding through various landscapes, catching fish of ever-increasing size, sitting in front of campfires in the snow. He's a recognizable self-portrait of yourself, of course, a combination of alter ego and Everyman. And he adds a definite story-telling aspect to your work . . . even an element of the "tall-tale" that Peter White commented on in his essay for your Calgary show catalogue.[1]

GH: You know, in the beginning I wasn't conscious of the Kernal being my alter ego. And I didn't intentionally paint him to look like me. But, of course, he is and he does. I do like to think of him as Everyman.

I think Peter White's comments were pretty perceptive . . . I often paint the Kernal in a situation that is larger than life. It's usually perilous, too. Although he's often somewhat aloof to the whole thing. In one episode he's riding between giant dog heads, but he is unruffled by the menacing situation that confronts him. It's very important to keep your tongue-in-cheek in just the right way or else you can get real stupid pretty fast

I don't always laugh at my own work, but the other day a friend was looking at *Kernal with Fire and Wolves* and started laughing. I started laughing at it with him. It was nice. I suppose we were laughing at the kind of situation we as humans find ourselves in quite often

[1]See Bibliography

PW: The smoke blowing in the Kernal's face

GH: The smoke in your face and the wolves behind you! And there you are!

PW: The same thing is happening to him in *Kernal in Winter Woods*. The smoke is blowing straight into his eyes

GH: Yes, and I've made him fairly passive again. He's not interacting with the elements in an overt way, or gesticulating, or trying to wave off the smoke, or anything. I suppose I instinctively refrain from making the figure too active. I don't want to become melodramatic. That would also tend to make it an illustration. When you're dealing with subject matter as I do, one can get into illustration. I'm not sure, but I think the difference between the two is that illustration seems to take place in time, and painting is taken out of time.

 I don't have anything against illustration, but it tends to depict an action that's taking place right in front of your eyes. I think paintings create their own space and their own time. I want them to be fiction, not to pose as reality.

PW: You spoke once about "staging" a painting as if you were conscious of dramatizing its component parts.

GH: Right. Well, I once was quite influenced by John Cage and others of that kind. That led me to look at a whole lot of things that I might not otherwise have seen. I found the world to be full of very fascinating objects and things to hear and see. And at one time I wasn't even sure that painting paintings was all that significant any more. But now I think the fact that you can bring together certain elements in a selective way to produce drama, visual drama, is still important. The selectivity of the process, what you leave out and what you include and how you put it together, does bring about something that you don't find in nature itself. Regardless of how many other wonderful things are out there in nature, painting is a different thing. I suppose that's one reason painting hasn't died out yet, or poetry, or story telling.

PW: Yes.

GH: To get back to your question. I do sometimes think of the canvas as a stage where any number of things might appear. Just think of how many things there are out there that could come onto the canvas. Why some things appear rather than others is interesting to contemplate. Or something may come in and go out again. Or several objects having nothing to do with each other may appear. This happened, actually, in the painting with the title *While a Lady Swings, Three Dogs Pass By, One Stepping on a Tulip*. The only relationship these objects and their actions have in common is that they exist on the same canvas The empty canvas is a pretty curious space for me!

PW: So far we've talked almost exclusively about subject matter, but I know, from what you've said before, that a lot of other elements are still more important to you in your painting. Surely your concern with composition, arrangement, and other formal qualities accounts for at least part of this curiosity in the empty canvas?

GH: My interest has never been first and foremost in the subject matter as such. What I'm really fascinated by is the whole idea of why things end up where they do. My choice of subject matter is usually tied into some kind of painting idea. For example, in *The Kernal in Winter Woods*, the Kernal's black coat, hat, and boots are turned into dark shapes to contrast with the prevailing off-whites of the snow. I tried to keep the subject simple—and this may be where the primitive-like comes in—so I could more easily turn the subject into form, into shapes and color and placement. The smoke from the campfire becomes a spatial and dimensional form, rises from the fire, cuts across the Kernal's face, goes behind some trees, and ends up at the edge of the painting. But that's not the whole story. If you're leaning in an expressionist direction, as I do in this work like many others, then there's a psychological connection between subject and form. Your feeling for the subject influences or determines composition, color, the way the paint is applied.

But, despite what I said just now, I am not afraid of subject matter. I don't think it ruins a good painting. I've stood in front of Rousseau's *Dream* and have experienced it as pure visual music. I've also been enchanted by the content. I'm pretty good at switching back and forth that way. You know some of the purest painting around is East Indian painting and almost all of it is narrative. I enjoy a good non-objective painting as much as anyone but not because it doesn't have subject matter. It's because it does what it does very well within its limitations. Every kind of painting is defined by the limitations imposed by the artist. You can't have subject and no subject at the same time. However, you can have subject matter and formal qualities at the same time.

In other words, subject matter is a way of permitting you to enjoy the aesthetics of a painting less self-consciously than if you were looking at pure painting. With pure or non-objective painting, you're looking straight at pure art. I sort of like the fact that subject matter gives you some relief from that. You're not getting a straight dose of aesthetics when you look at the work.

I guess I've thought this way for quite a while Well, to flash back a little. . . . When I was around twenty I went to New York. I was quite conscious then of the Museum of Modern Art versus the Metropolitan Museum, and I used to shuttle back and forth between the two. I liked what I saw in each museum, but the Museum of Modern Art obviously seemed to have paintings with a different kind of impact than the Old Masters of the Metropolitan. As a matter of fact I had done some non-objective paintings in my late teens before I actually knew such things existed. So I had been interested quite early in various kinds of modern art, particularly abstract and non-objective painting. I still very much admire that sort of painting.

There were, however, some doctrines that I thought a little dogmatic. For example, the notion that if you included subject matter in a painting you created some kind of awful dichotomy that split your mind. That struck me as being rather stupid because I didn't feel that way in looking at East Indian or Egyptian or even Renaissance painting. I didn't feel that something terrible was happening to my mind. Although having done non-objective painting, I recognized that there was a particular harmony to looking at a work and experiencing the form directly without it meaning something else. On the other hand, I felt there was a fascinating quality about the play back and forth between the form and the content, which one needn't find at all upsetting, but rather pleasureable and exciting.

PW: Did you admire any non-objective artists in particular?

GH: My art career goes back to 1940, you know. That's when abstract art started making pretty good headway amongst the other "isms" of the time. Kandinsky and Mondrian stood out for me then, and still do, particularly Mondrian. Of the more geometric kinds of abstraction I prefer the more minimal. I don't particularly like it when there are too many relationships going on between forms. I would rather see a white on white square, because I suppose to me it's more specific. In some funny way it ties in with my attitude now Then, of course, there was Picasso and Braque and Matisse and Brancusi. All were giants to me, and still are

PW: You yourself worked in an Abstract Expressionist mode for many years from the late forties. You must have become quite familiar with it as a vehicle.

GH: Yes, that was a great movement, too. I thought de Kooning and Rothko were particularly strong. But basically Abstract Expressionism wasn't suited to my personality. Quite a number of artists were attempting to do Abstract Expressionism and really weren't suited to it. Not everyone is inclined toward that kind of heroic painting. Also I couldn't make paintings as specific as some of the other painters made theirs. I had a tendency to get too much into nice relationships of color, making the thing visually interesting rather than creating a painting

that had a strong presence. I think I did a few that managed to come off pretty well, wherever they happen to be now . . . probably burned.

PW: Is there any legacy that your involvement with Abstract Expressionism has left in your work?

GH: Yes, I would say that I do utilize, not techniques, but some of the formal concepts of Abstract Expressionism. Probably there are paintings I'm doing right now that are formally closer to Abstract Expressionism than the paintings I was trying to do then!

PW: I was about to make the same comment! A concern with formal elements, with the balance of the objects in your paintings, seems to be particularly important to you. Certainly some of your works make the same simple, pure statement that an abstract work can. But then it seems to me that equally purposefully you place things to create imbalance, asymmetry

GH: I *am* fascinated by placement within the painting. You can approach arrangement and composition from the standpoint of achieving a kind of wonderful visual order or you can approach it from the standpoint of achieving a particular expressive effect where order is not necessarily emphasized. A canvas that's loaded with objects has a very different effect than one that's very simple and has maybe one or two objects. And, of course, the actual size of an object in the space has something to do with the effect it has. If you fill a canvas totally with a big dog head, that's very different from putting a little tiny dog head in the middle of the canvas. I often enjoy a centrally-placed image if I want to emphasize the image itself, the essential existence of the object, and not how it's relating to this, that, or the other thing. On the other hand, some forms of expression, some specific ideas, call for an asymmetric approach.

Once, in experimenting with this sort of thing—I was living alone at the time—I pushed all the furniture in the living room off to one side so the other side was bare. It was fairly revealing.

PW: You've said before that Giorgio Morandi's work was influential in forming your ideas about placement.

GH: Yes. In the sixties, Iain Baxter and I discovered Morandi. Iain was a fine arts graduate student at the time and we explored a lot of art ideas together. One of the things we did was to play with objects on a table. We suspended any kind of aesthetic preconceptions. And we discovered that objects could be put in any way they could be physically put. We found that we could put the objects in the center, on the edge, at the corners, or wherever . . . and that each kind of arrangement yielded a different but specific effect. Some arrangements had a stronger presence than others.

It seemed that Morandi's bottles also arrived at their particular placement partly by chance. They didn't have a calculated feeling of arrangement. He would have a vase in front of a pitcher so that you just barely saw a little bit of the handle of the pitcher and a little bit of the neck or lip. It was a relaxed, informal look, but it had a feeling of finality.

I was coming from Abstract Expressionism. The thing that Morandi did was to play out relationships between objects in a very specific way. His objects touched and overlapped—it was a sensuous thing. There's a lot of difference between touching and not touching. He also gave his bottles and pots a definite identity by bringing out their essential shapes and features. And he had such a strong clarity of image. You could back up a mile from those little paintings and they'd still be as strong as could be.

Anyway, placement and the decisions that go with it are very interesting to me. The question of why one accepts certain arrangements and not others The mind is a fascinating instrument

PW: You're particularly interested in the mental processes of artistic creation. We've talked before of the involvement of the conscious mind and the role of intuition in the process. Could you expand on some of your thoughts along these lines?

GH: I think that when we say we're working intuitively, then the mind is really working in the way it's supposed to. It's not shut off. The images that come into your brain come not so much by willing them as by allowing them. I make a distinction between thinking up an idea and an idea coming to you. Although you can help the process along by creating some kind of an environment where the brain will let things come.

I think the mind really prefers some kind of order to disorder. In the process of creating, you present your mind with a situation that calls for either problem solving or making an idea more coherent. You move from a kind of incoherent situation where you're not really grasping ideas very completely to a situation where ideas become more coherent and complete.

In painting, it seems to me there's a good deal of the incomplete or even the chaotic. You're dealing with situations where the painting hasn't settled into what it's finally going to be. The mind somehow has to bring some kind of unity to the work. In other words, you may be working on a painting and things come to a point where it just doesn't hold together. It doesn't necessarily help to pick at it and use the artistic devices you've learned. The mind still has to get hold of the painting as a totality and come up with a feeling of what the painting is going to be, and then you physically, with paint and a little activity of your own hand and arm, bring that about.

But then, of course, the mind may prefer to work with something it already knows and not be involved with these uncertainties and new ideas. It would rather work with old ideas.

PW: So you have to push it?

GH: Right. Your mind has to understand what your mind is doing! If it's sinking into stereotypical thinking, you have to jar it loose from that in some way or another.

PW: When you talk, as we have been, of the mental processes of artistic creation, of your formal concerns with placement, of your evident first-hand knowledge of twentieth century art movements, then it seems ironic that people, certainly some reviewers, have seen you as a true primitive or an instinctual folk artist. One senses that the implication is that you are unschooled, whereas clearly you are well-versed in the ways of contemporary art.

GH: Well, you know, Henri Rousseau has always intrigued me because I've always felt that if he had elected to, he could've painted more realistically, or in a more impressionistic fashion, or whatever. I always felt that he painted as he did because he understood and appreciated the fact that he was doing the job very well that way. I think Rousseau was much more intelligent than some people led us to believe and experimented quite consciously with approaches to painting.

PW: Then like Rousseau, you've elected to paint less realistically, some would say less sophisticatedly, than you are able?

GH: Yes, I'm capable of quite good realism, believe it or not. I was a very accomplished draftsman, knew anatomy thoroughly, could draw and articulate the figure well.

At any rate, I don't feel that an individual is born to paint a certain way. It's usually cultivated. But you have to feel right about what you're doing.

PW: So what feels right to you? How do you decide what approach to use?

GH: Well, since I've worked in so many different styles and have taught so many of them, I have a whole history to contend with, which in some ways is valuable but often gets in the way. I can opt to paint more realistically. I can model a form more or less as I see fit, etc.

But what has to happen is I have to become involved in a particular painting in such a way that the painting knows what it wants to be. In *Fish on Stage* on the wall over there, the fish is modeled more than in some other works. It also casts a shadow. The figure of the Kernal is more primitive. So the painting is inconsistently handled, which is okay as long as it works.

The fact that I have done paintings that lead some people to believe I'm an honest-to-

goodness naive painter right from the start amazes me. It must be because I get into a way of thinking that's like the way naive and primitive painters think. And I don't see the description "primitive" as a criticism of my work. I do admit to being partial to primitive, naive, and eccentric works, and some folk art.

I did do a painting of stampeding buffalo that really looked like a primitive painter had done the work. It didn't have the usual stylistic devices that you associate with artists who've gone to graduate school or who are part of the art scene of New York. It wasn't obviously *artful*. But it did have basically good shape, color, and figure/ground relationships.

PW: Did you distort the buffalo consciously to make them appear more folk-like?

GH: To me they aren't so much folk-like as they are primitive-like, but I didn't set out to make them that way . . . to look primitive. Cave paintings could have been in the back of my mind. The buffalo running were painted from a feeling for buffalo running. I tried in a direct way to express this dramatic event by the way the buffalo are placed and by emphasizing the buffaloes' essential features. If there is distortion, and no doubt there is, it's done intuitively for formal reasons and for dramatic effect.

Then again, as far as distortions go, I often make dogs' eyes larger and their legs too big. And I don't necessarily bend their paws in the right way. In situations like that I think that an artist has to rely on his instincts as to whether it works or not. It's a chance you have to take.

Well, I could draw any of these objects much more accurately if I wanted. But I like it when I can do a symbolic statement of an object that has the feel of the original if not the exact form. My dogs are, to a certain extent, caricatures. The distortions make them more effective, more powerful.

PW: Isn't caricature to do with recognizing essential characteristics and emphasizing those so that they become more recognizable?

GH: Well, I've been aware that Audubon's birds,

pretty as they are, are not very convincing. His magpies, for example, have none of the real characteristics of a magpie. They look somewhat stuffed and don't have a sense of energy and movement and mischief. The gesture, the body-language of the bird, can't be expressed well in a highly rendered realistic approach. So there are certain things you cannot do with realism, which is why we have a variety of art. One kind cannot do it all.

PW: Following along on the ideas of caricature . . . it is usually seen in conjunction with humor . . . and your work is certainly humorous.

GH: How anyone can be alive, particularly these days, and have no feeling for the absurd, I don't know. Humor is a way of dealing with the seriousness of it all.

Humor has, of course, to do with the juxtaposition of things in a way that is unexpected: two things totally divorced from each other happen to come together at some point. What I found is that you do something that seems to be fairly preposterous, but then you find out that it's really happening out there

I did a painting of dogs attacking tulips. It partly came out of the fact that one spring a whole lot of new tulips came up all over the yard. They were very prominent. They're big, fleshy kind of plants, fairly strident flowers, which was initially what I didn't like about them. But then I got to liking that quality. . . . At any rate, I had a painting where dogs were attacking the tulips. Then two or three years later I planted a zucchini squash and it was doing beautifully, until the neighbor's dog came over, attacked it, tore it up, and bit it to pieces!

PW: You had tulips attacking dogs, too, didn't you?

GH: Yes, I had a tulip swallowing one. Well, that was kind of a fanciful thing. I haven't seen that actually happen. However, there are plants that do eat insects and probably could manage a small rodent.

Nature is really a bizarre place. When my dog was half grown, it collected objects and placed them on the lawn, inside a very definite perimeter. It would rearrange the objects and sit and look at them. The collection was quite varied and interesting. It collected all over the neighborhood. Dug things up. Some were quite nasty, in fact, I called the dog "Rancid" for a while because of the horrible things it brought in

Then I did a painting of a wolf-like dog taking a bite out of the moon. I like that painting a lot because it seems particularly convincing, as though it is actually happening in front of you. I mean, it defies the usual laws of reason. And I guess that, when something impossible is being depicted as actually happening, and it indeed seems possible, that's interesting.

PW: Your paintings are full of the impossible happening: flying ducks with flying fish following them, giant dog heads popping out of a hillside

GH: Yeah. It tickles me when our usual, rational side is challenged in some way. Particularly within a painting where it's not going to harm anybody. It's kind of fun to make some of those impossible things happen. I try to make these events seem as though they were a normal, everyday occurrence. I don't try to make out as though they're some kind of abnormality. Otherwise I think it would be kind of dumb.

I take humor quite seriously and mine's somewhat deadpan. I believe, as most people would, that humor is part of being serious and that it's a legitimate way of dealing with life. Contemporary art, generally speaking, has not been involved too much with humor. Except for artists such as Miró and Rousseau. I mean you can't look at that wonderful lion in total seriousness!

PW: Yours may be an absurd humor but it's also gentle. To me it ties in with an optimistic view of nature. Others have spoken of your work as being concerned with paradise or Arcadia. Are you that optimistic?

GH: For a person of Danish ancestry, I seem to be taking a fairly positive approach to life in general. Although I don't feel that light-hearted much of the time. But I do have moments when I'm fairly upbeat. Maybe it's because I'm quite serious other times that I appreciate the lighter side. I suppose many humorists are fairly serious people. I certainly hope I'm not doing a kind of "ha-ha" humor!

Some of the work I've done reminds me of Gerard Manley Hopkins and his "glory-be-to-God-for-dappled-things." Yeah, I admit to having that side of me and I'm pleased when it comes out. I don't try to inhibit it. And as for paradise or Arcadia, that's one side of me reflected in a painting like *Fish in a Landscape.*

But I think some of my other paintings are darker than that. They have more of an edge to them. The Kernal caught between smoke and fierce-looking wolves, for example. And *Bound Dog* doesn't have much to do with humor or Arcadia.

PW: Were those darker paintings a reflection of your emotional standpoint at the time?

GH: *Bound Dog* probably did reflect my emotions at the time it was painted. But I don't regard it as a form of self-expression. I think such works reflect the fact that life is full of a number of things. I have experienced a certain amount of tragedy and difficult times, as have most of us who've been around a while. I would be surprised if some of this hadn't gotten into my paintings. The thing is, I don't feel one has to be heavy all the time in order to express life. I think enchantment, exuberance, humor are wonderful things to achieve if you can. Knowing all the hazards of life and all the tragic things that happen, I think it's okay to create a sense of enchantment. If I can do that from time to time it's great. That's a form of profundity, I suppose.

23

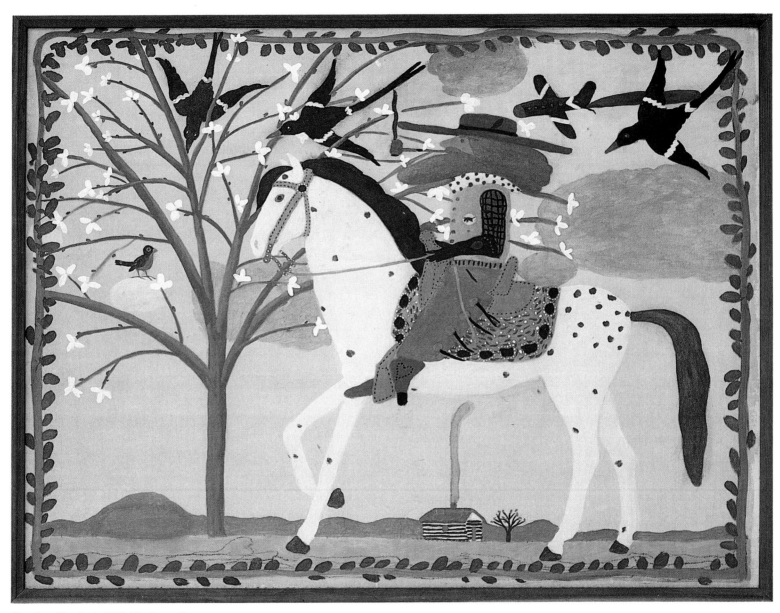

Kernal on Horseback, 1975 (Catalogue 1)

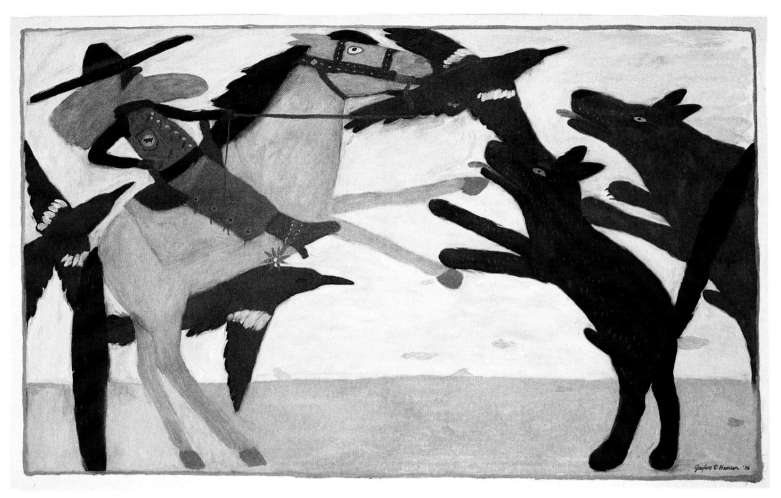

Kernal and Two Dogs, 1976 (Catalogue 2)

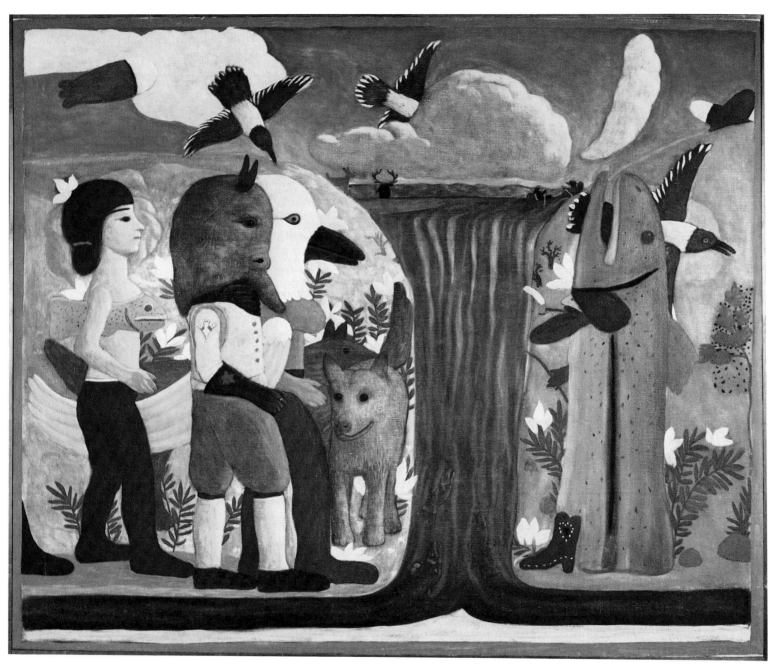

Meeting at the Waterfall, 1976 (Catalogue 3)

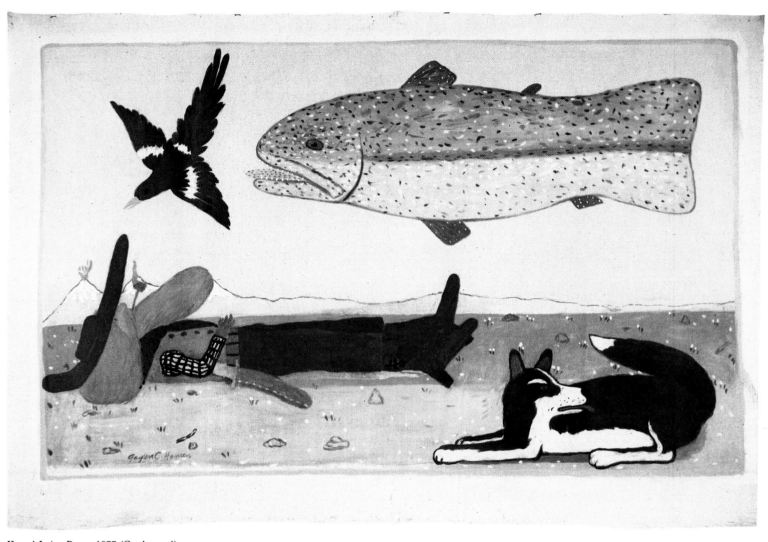

Kernal Lying Down, 1977 (Catalogue 4)

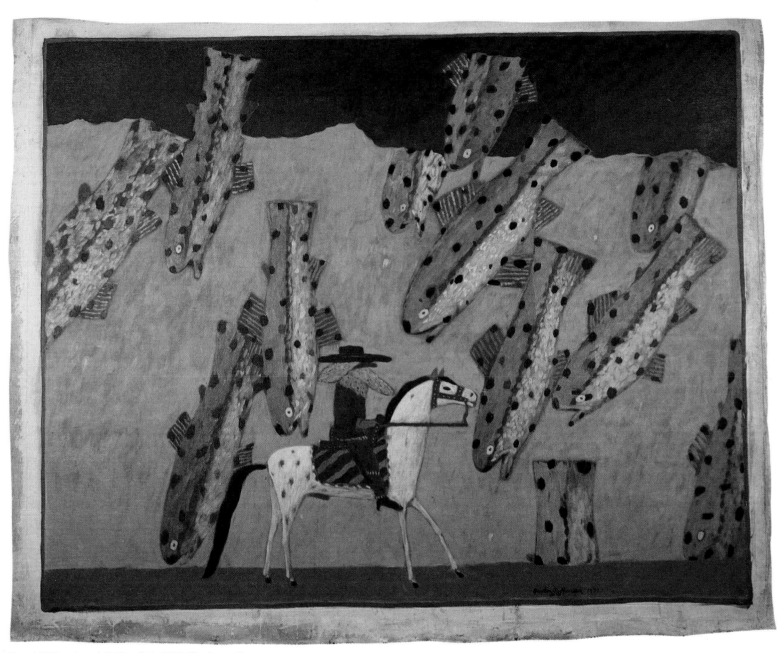

Kernal Riding through Falling Fish, 1977 (Catalogue 5)

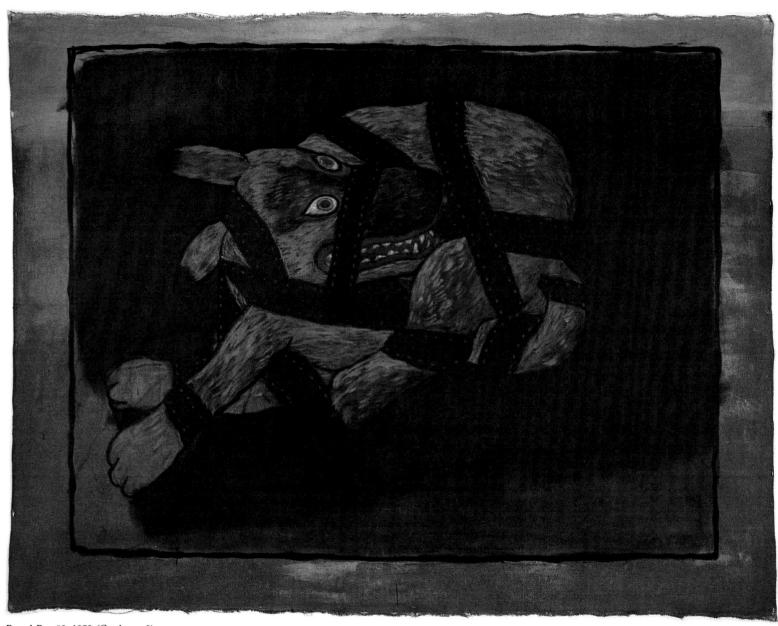

Bound Dog #2, 1979 (Catalogue 9)

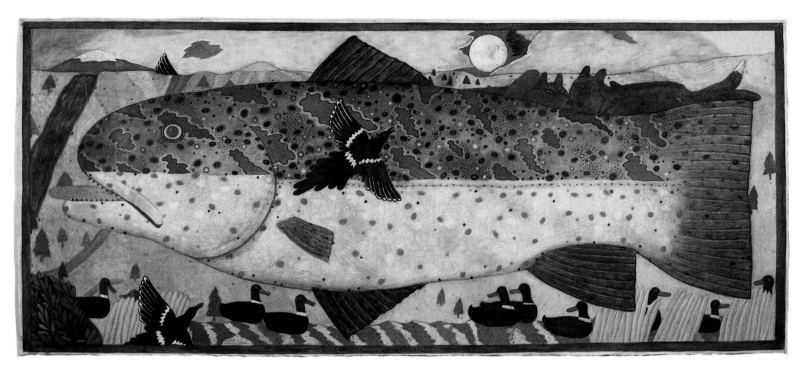

Fish in a Landscape, 1979 (Catalogue 11)

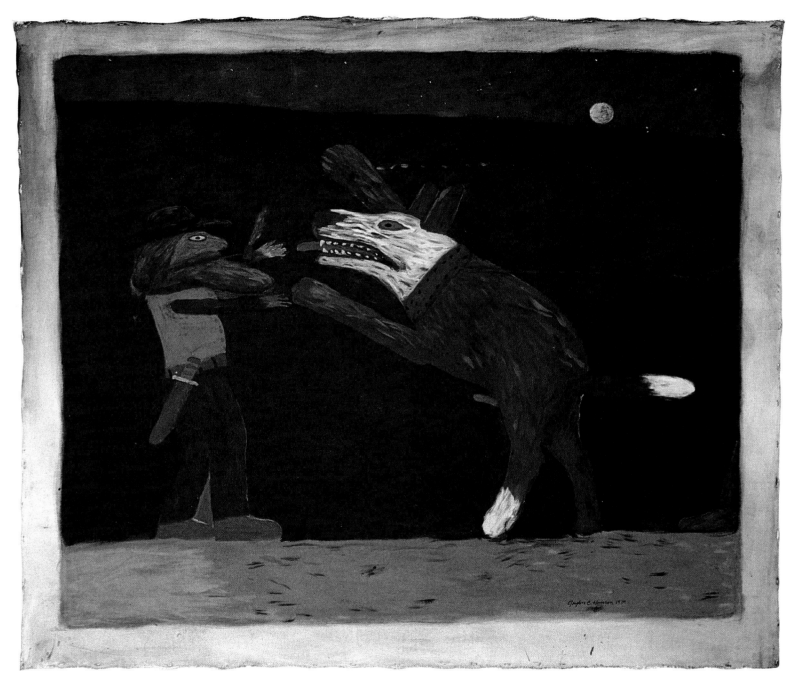

Encounter, 1979 (Catalogue 12)

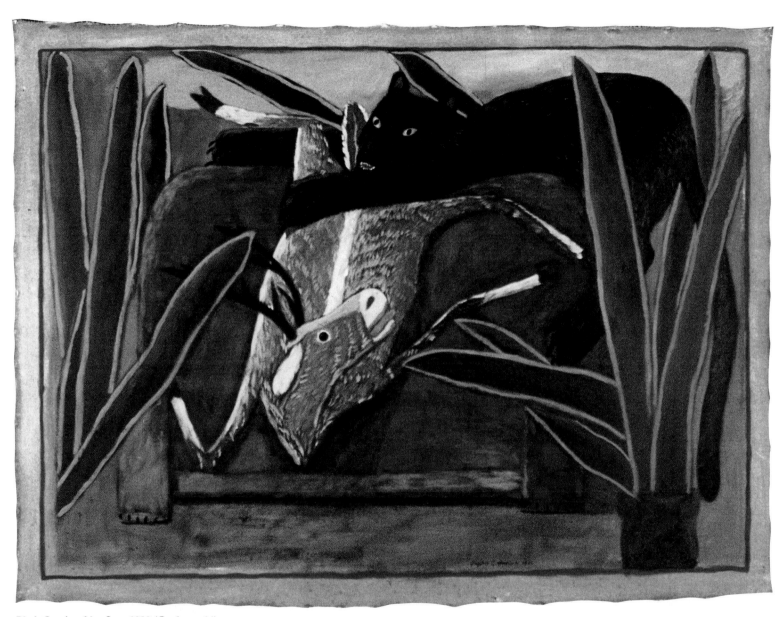

Black Cat Attacking Stag, 1980 (Catalogue 14)

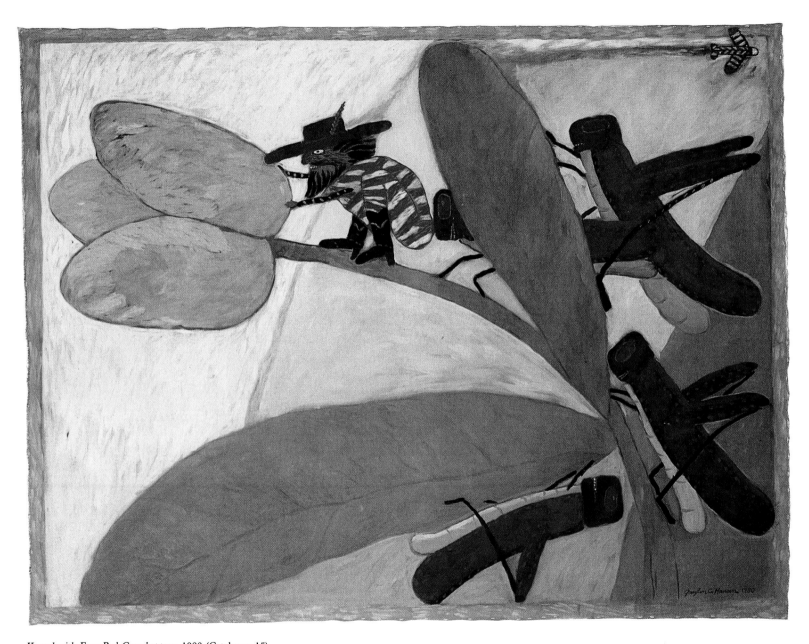

Kernal with Four Red Grasshoppers, 1980 (Catalogue 15)

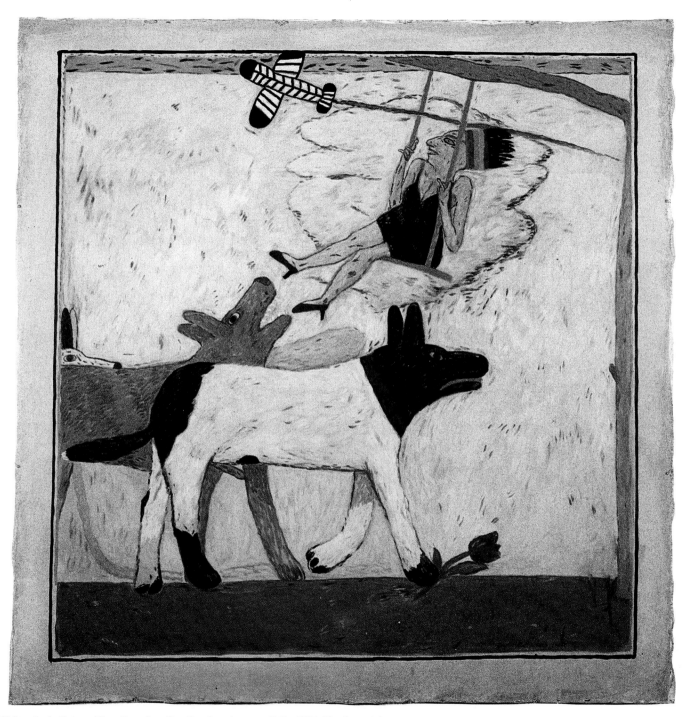

While a Lady Swings, Three Dogs Pass By, One Stepping on a Tulip, 1980 (Catalogue 16)

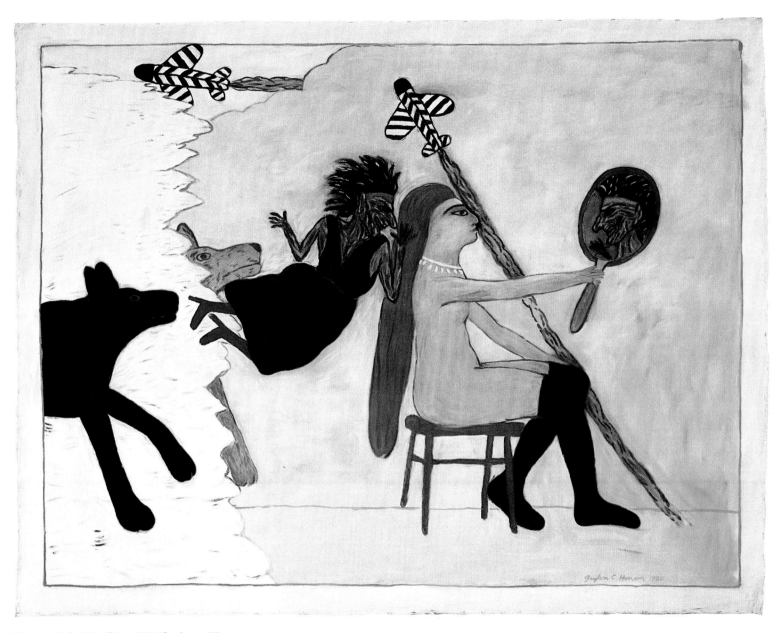

Woman with Looking Glass, 1980 (Catalogue 17)

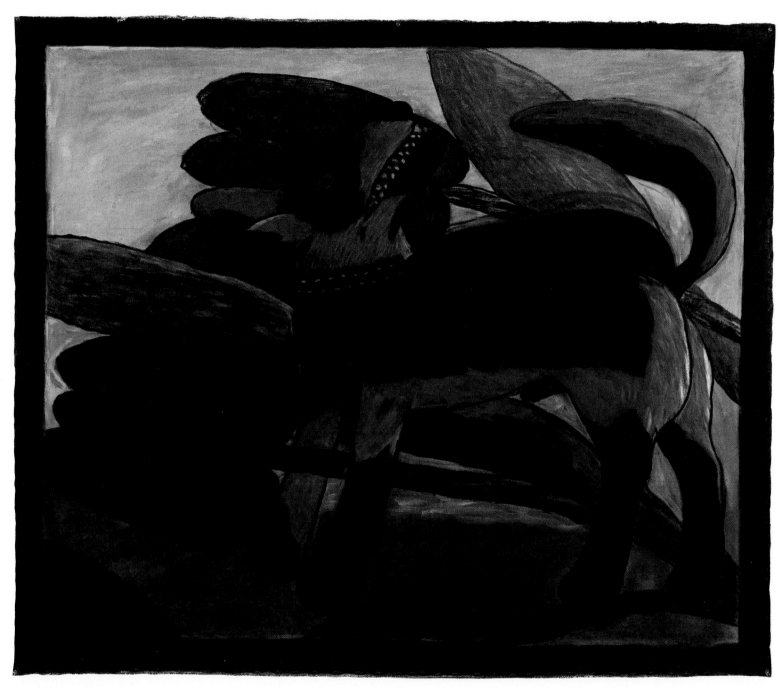

Big Dog, 1982 (Catalogue 18)

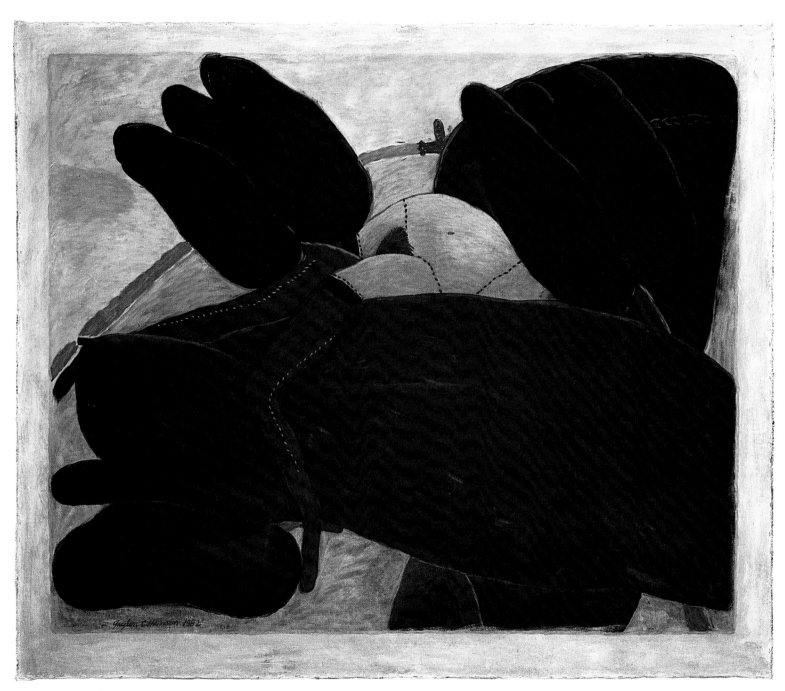

Three Tulips, 1982 (Catalogue 20)

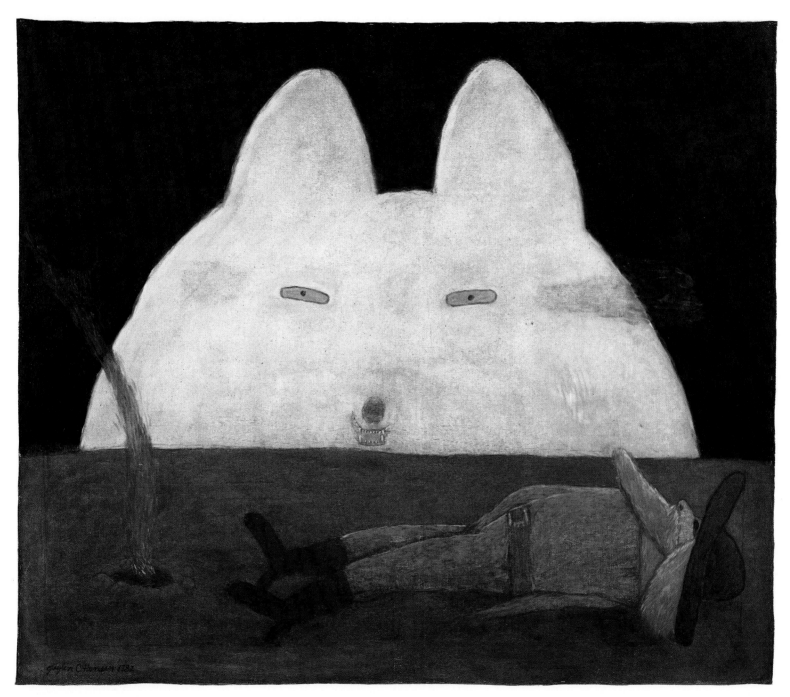

Rising Dog, 1983 (Catalogue 21)

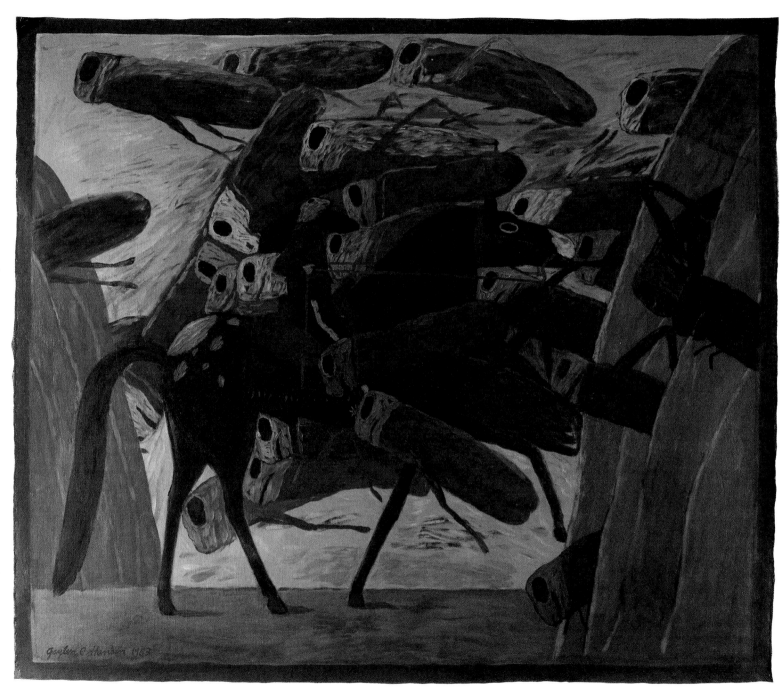

The Kernal Encounters a Swarm of Crickets, 1983 (Catalogue 23)

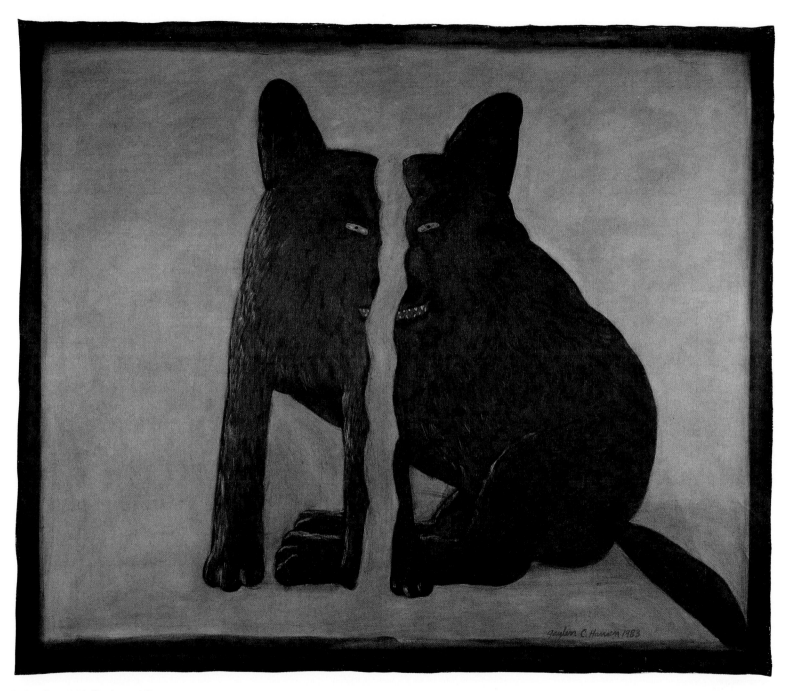

Broken Dog, 1983 (Catalogue 24)

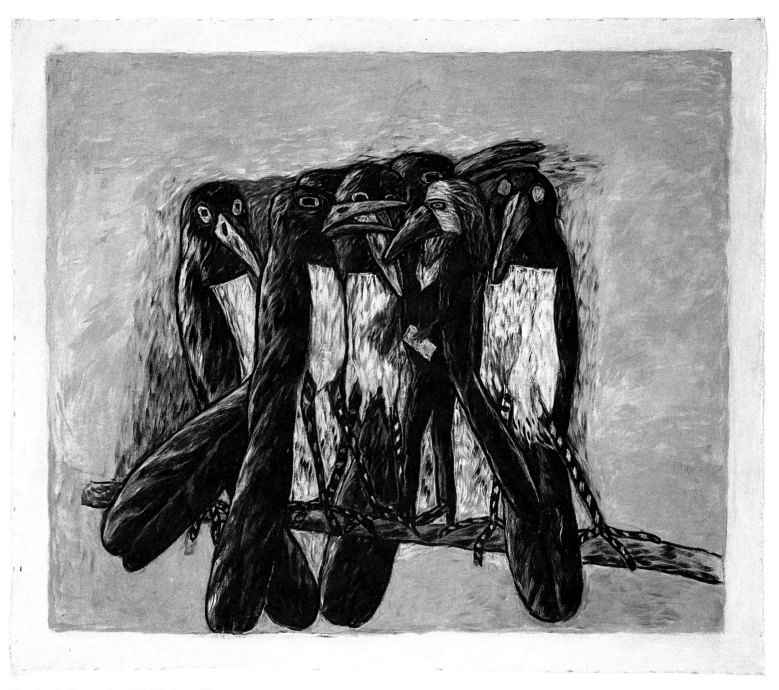

Kernal at the Presentation, 1984 (Catalogue 27)

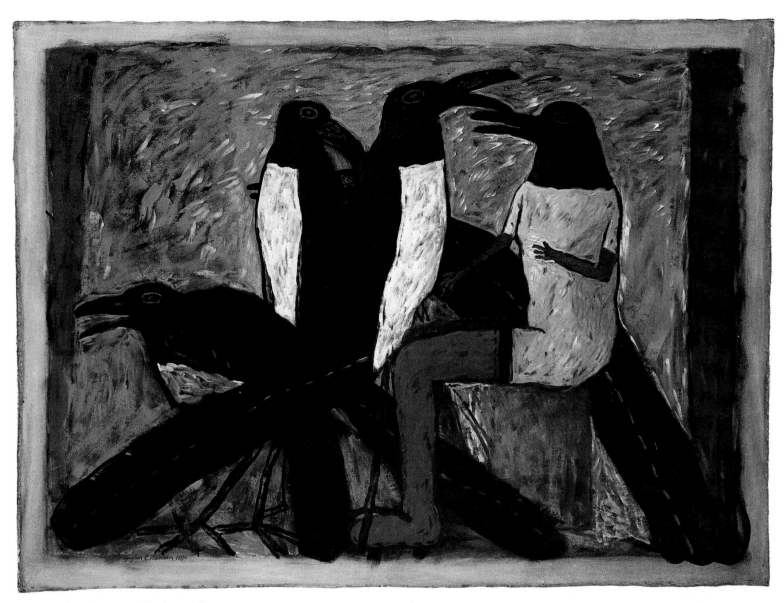

Birds with Pink Torso, 1984 (Catalogue 28)

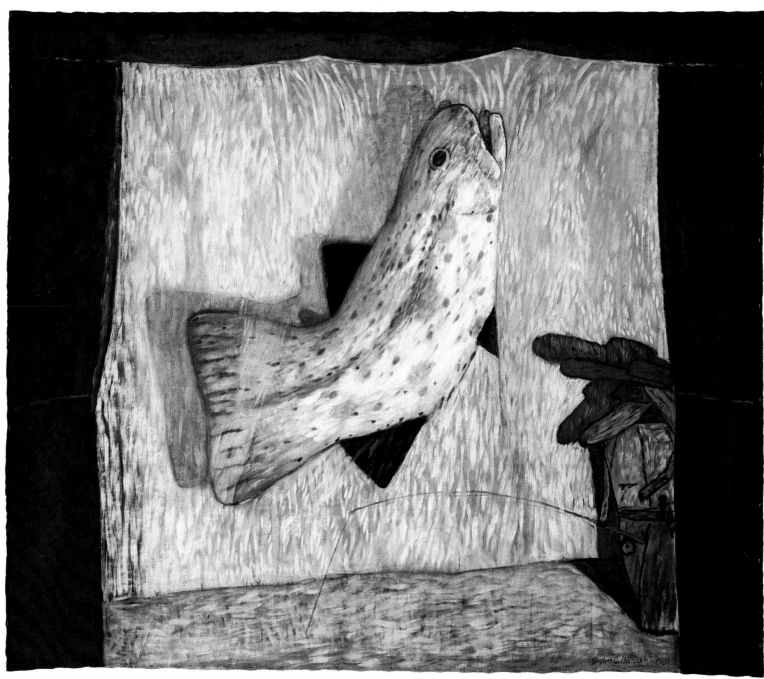

Fish on Stage, 1984 (Catalogue 29)

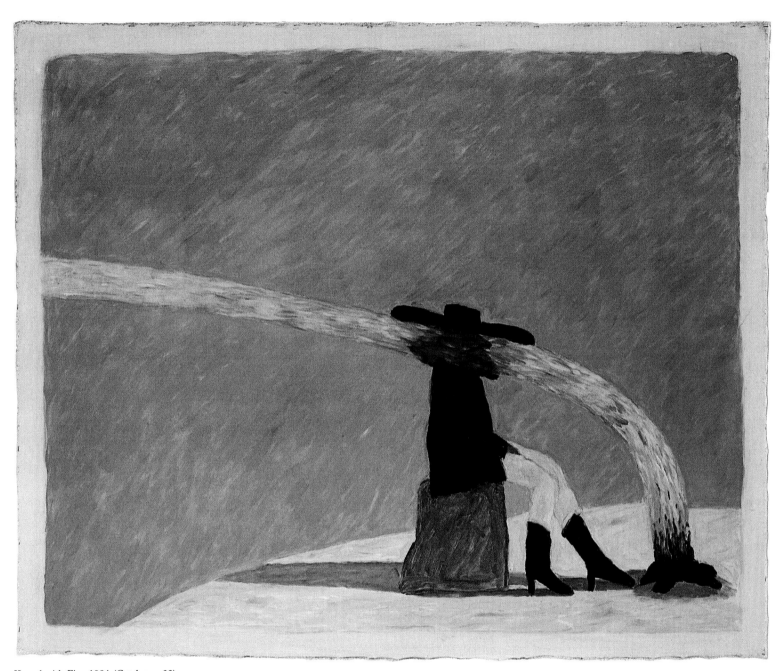

Kernal with Fire, 1984 (Catalogue 32)

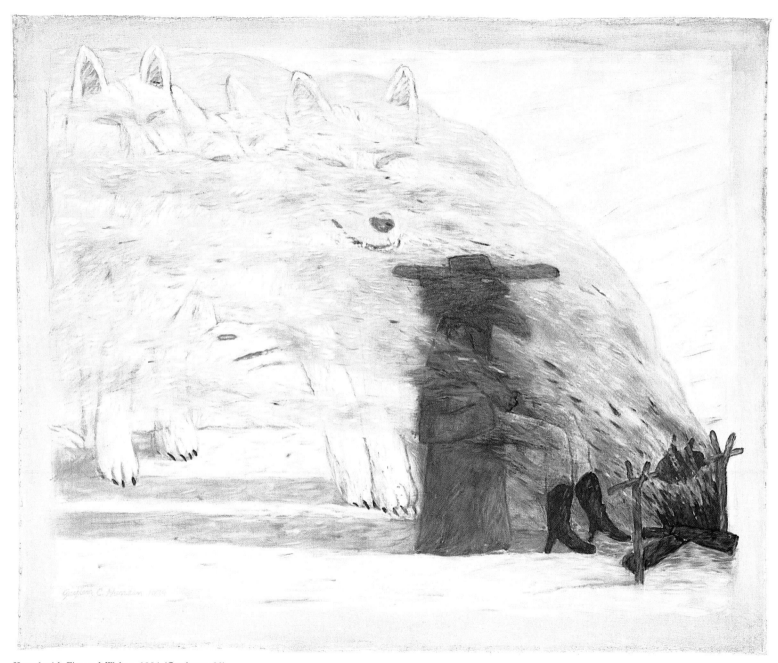

Kernal with Fire and Wolves, 1984 (Catalogue 33)

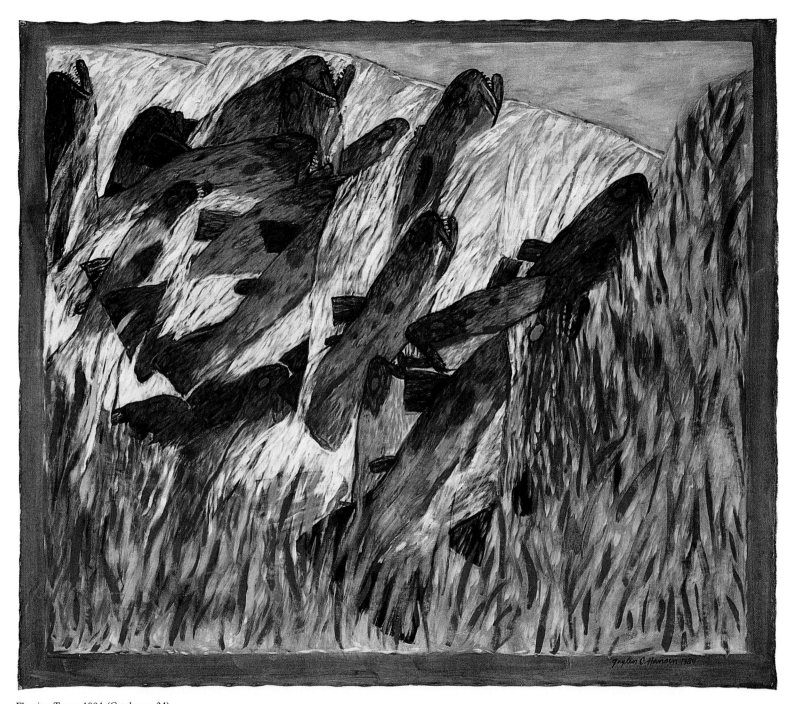

Flaming Trout, 1984 (Catalogue 34)

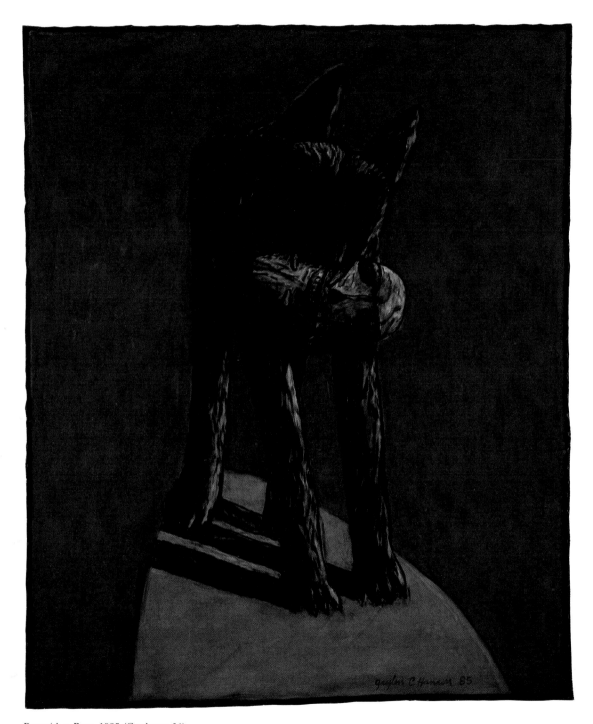

Dog with a Bone, 1985 (Catalogue 36)

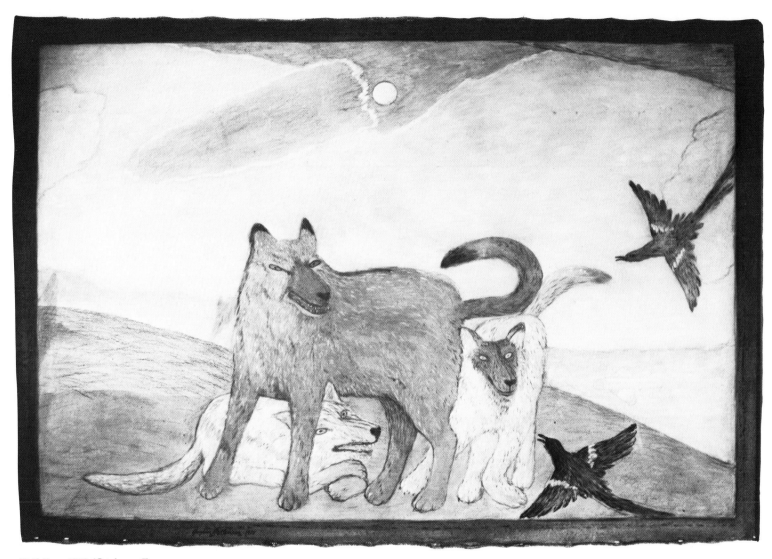

Wolf Dogs, 1978 (Catalogue 7)

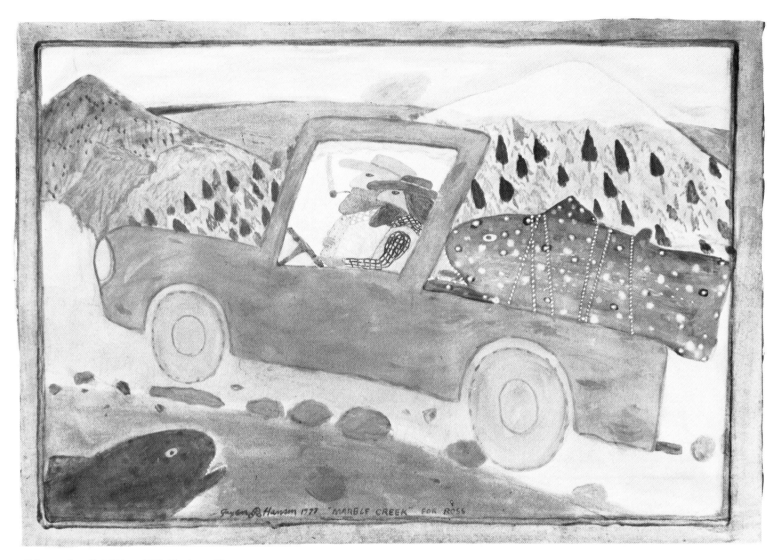

Fishermen in a Red Pickup, 1978 (Catalogue 8)

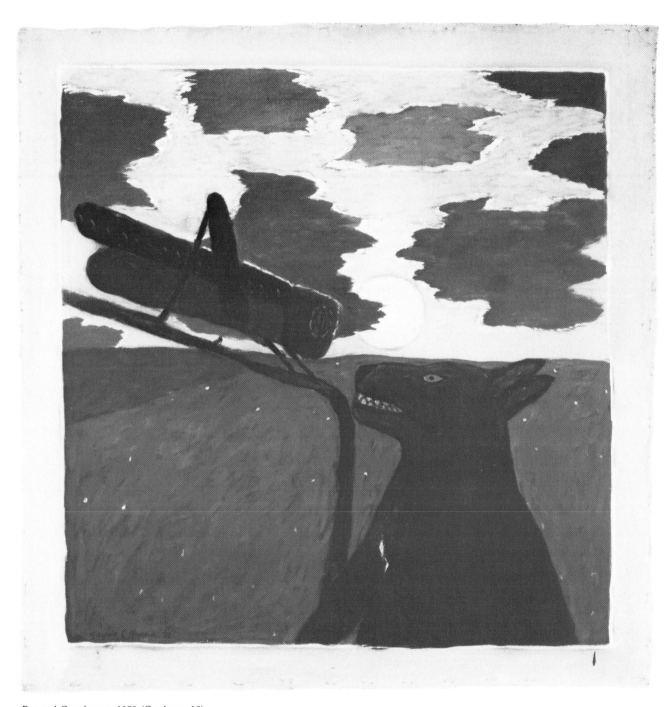

Dog and Grasshopper, 1979 (Catalogue 10)

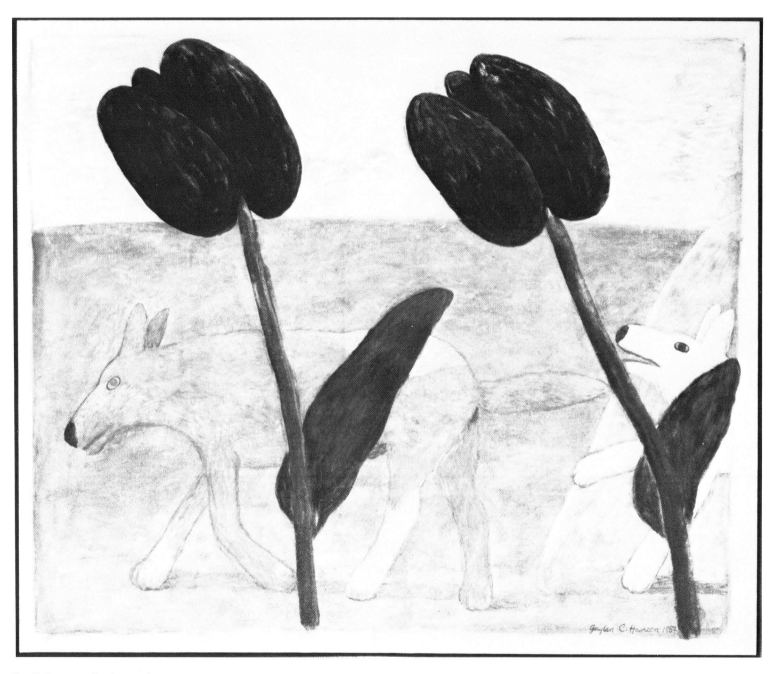

Two Tulips, 1982 (Catalogue 19)

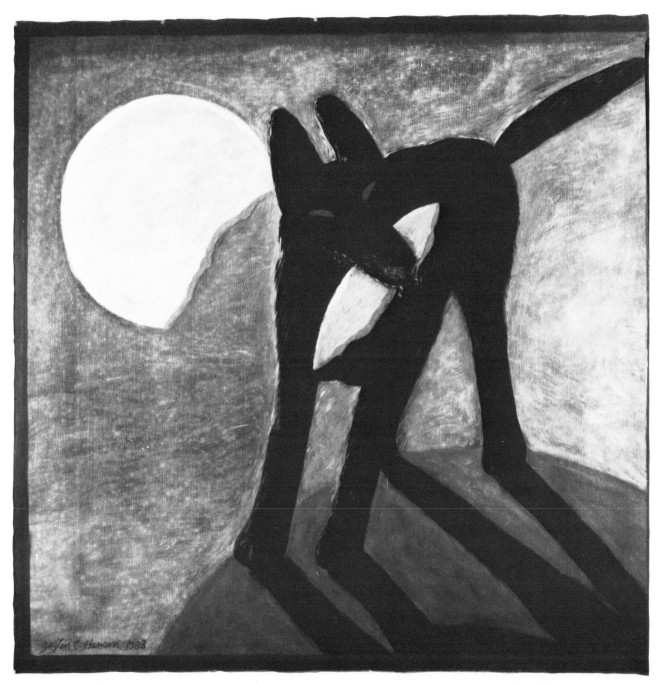

Dark Wolf-Dog, 1983 (Catalogue 22)

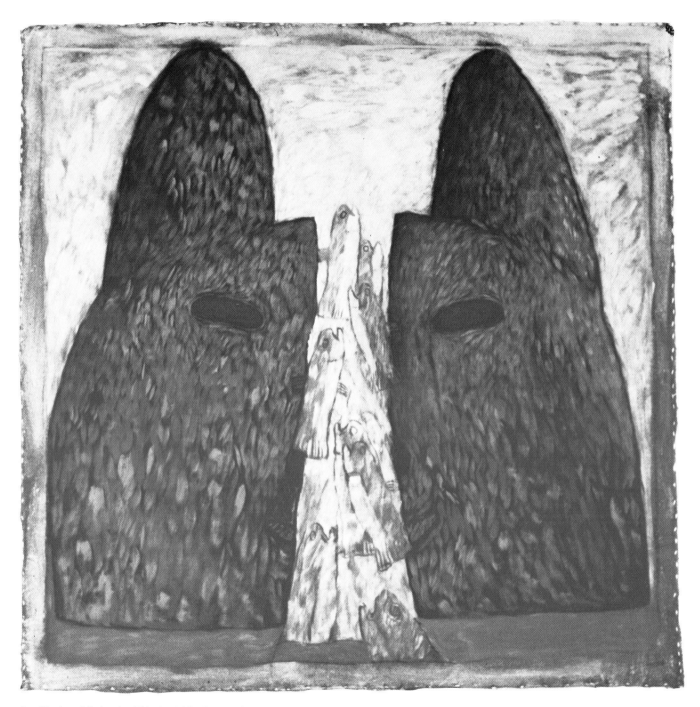

Dog Heads and Swimming Fish, 1984 (Catalogue 26)

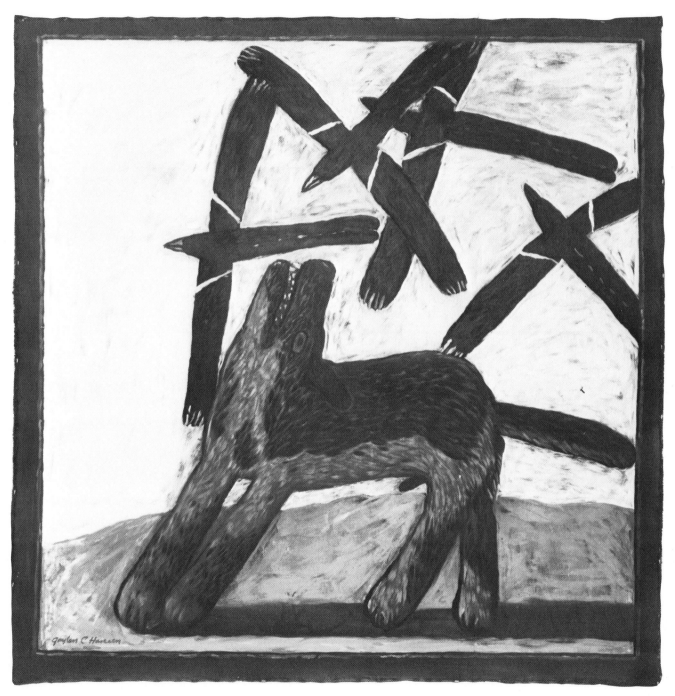

Dog Dive-Bombed by Birds, 1984 (Catalogue 30)

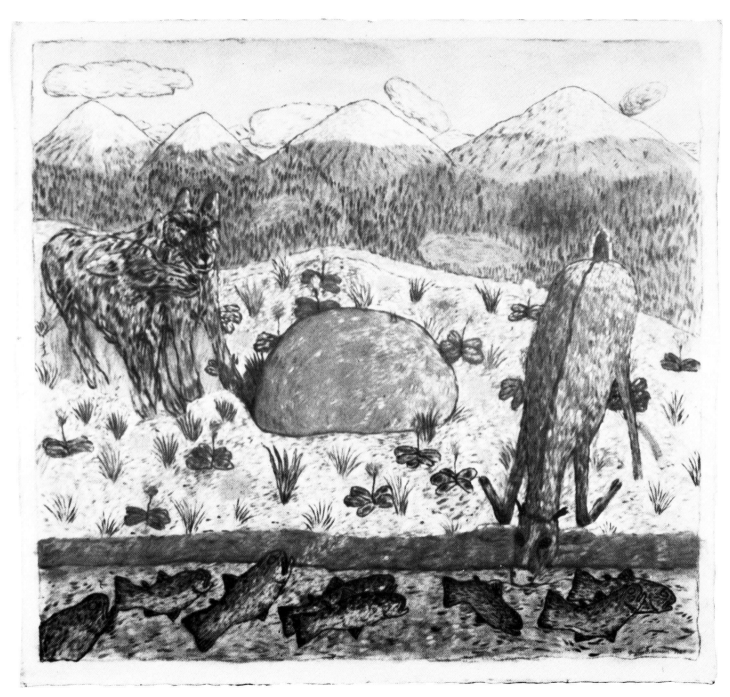

The Rock, 1984 (Catalogue 35)

CATALOGUE of the EXHIBITION

1. *Kernal on Horseback,* 1975
 oil on canvas
 36 x 58"
 Collection of Patrick Siler, Pullman

2. *Kernal and Two Dogs,* 1976
 oil on canvas
 41 x 67"
 Collection of Jack and Dorinda Schuman, Pullman

3. *Meeting at the Waterfall,* 1976
 oil on canvas
 48 x 58"
 Collection of Patricia Cassidy, Pullman

4. *Kernal Lying Down,* 1977
 oil on canvas
 47 x 71"
 Private Collection

5. *Kernal Riding through Falling Fish,* 1977
 oil on canvas
 53½ x 36"
 Collection of Linda Okazaki, Port Townsend, Washington

6. *Kernal Fishing,* 1978
 oil on canvas
 36 x 46"
 Collection of Harvey and Franqise Rambach, New York

7. *Wolf Dogs,* 1978
 alkyd on canvas
 49 x 72"
 Collection of Patricia Cassidy, Pullman

8. *Fishermen in a Red Pickup,* 1978
 alkyd on canvas
 48 x 70"
 Collection of Ross Coates and Marilyn Lysohir-Coates, Pullman

9. *Bound Dog #2,* 1979
 oil on canvas
 55 x 71"
 Collection of Peter Millet and Sherri Markowitz, Seattle

10. *Dog and Grasshopper,* 1979
 oil on canvas
 35½ x 32¼"
 Collection of Nancy Kiefer, Yakima, Washington

NOTE
Dimensions: Height precedes width.
Gaylen Hansen is represented by the Monique Knowlton Gallery, New York.

11. *Fish in a Landscape,* 1979
 alkyd on canvas
 72 x 168"
 Collection of the Washington Jockey Club, Renton, Washington

12. *Encounter,* 1979
 oil on canvas
 60 x 72"

13. *Dog in a Garden Pretending to be Ferocious,* 1979
 oil on canvas
 60 x 72"
 Collection of Kimberly Wright, Honolulu

14. *Black Cat Attacking Stag,* 1980
 oil on canvas
 56 x 73½"
 Collection of John and Janet Creighton, Tacoma, Washington

15. *Kernal with Four Red Grasshoppers,* 1980
 oil on canvas
 73 x 95"
 Collection of the Museum of Art, Washington State University,
 Pullman. Gift of the American Academy and Institute of Arts and
 Letters, New York: the Hassam and Speicher Fund.

16. *While a Lady Swings, Three Dogs Pass By, One Stepping on a Tulip,*
 1980
 oil on canvas
 72 x 72"
 Seattle City Light One Percent for Art Portable Works Collection

17. *Woman with Looking Glass,* 1980
 oil on canvas
 72 x 96"

18. *Big Dog,* 1982
 oil on canvas
 60 x 72"
 Collection of RSM Co., Cincinnati

19. *Two Tulips,* 1982
 oil on canvas
 72 x 84"
 Collection of RepublicBank, Houston

20. *Three Tulips,* 1982
 oil on canvas
 72 x 84"

21. *Rising Dog,* 1983
 oil on canvas
 72 x 83"
 Collection of Chase Manhattan Bank, New York

22. *Dark Wolf-Dog,* 1983
 oil on canvas
 72 x 84"
 Collection of Robert and Lucy Reitzfeld, New York

23. *The Kernal Encounters a Swarm of Crickets,* 1983
 oil on canvas
 72 x 84"
 Collection of Byron and Pat Todd, San Rafael, California

24. *Broken Dog,* 1983
 oil on canvas
 72 x 84"

25. *Snake River Dogs,* 1984
 oil on canvas
 72 x 96"

26. *Dog Heads and Swimming Fish,* 1984
 oil on canvas
 72 x 84"
 Collection of Philip Morris Companies Inc., New York

27. *Kernal at the Presentation,* 1984
 oil on canvas
 72 x 84"

28. *Birds with Pink Torso,* 1984
 oil on canvas
 72 x 97"

29. *Fish on Stage,* 1984
 oil on canvas
 72 x 84"

30. *Dog Dive-Bombed by Birds,* 1984
 oil on canvas
 72 x 72"

31. *Kernal in Winter Woods,* 1984
 oil on canvas
 72 x 84"

32. *Kernal with Fire,* 1984
 oil on canvas
 60 x 72"

33. *Kernal with Fire and Wolves,* 1984
 oil on canvas
 60 x 72"

34. *Flaming Trout,* 1984
 oil on canvas
 72 x 84"

35. *The Rock,* 1984
 oil on canvas
 72 x 77"
 Collection of Robert M. Sarkis, Seattle

36. *Dog with a Bone,* 1985
 oil on canvas
 72 x 60"

BIOGRAPHY

Born in 1921 in Garland, Utah
Lives in Palouse, Washington

EDUCATION
Otis Art Institute, Los Angeles, 1939-40
Art Barn School of Fine Arts, Salt Lake City, 1940-44
Art Center, Salt Lake City, 1940-44
University of Utah, Salt Lake City, 1943-44 and 1945-46
Utah State Agricultural College, Logan, 1946-47, 1951-52, B.S., 1952
University of Southern California, Los Angeles, M.F.A., 1953

COLLECTIONS
AT&T, New York
Chase Manhattan Bank, New York
The Cleveland Clinic Foundation, Cleveland, Ohio
Continental Bank, Chicago
E. F. Hutton, New York
Kidder, Peabody, & Company, New York
Patrick J. Lannon Foundation, New York and Palm Beach, Florida
Museum of Art, Washington State University, Pullman
Philip Morris Companies Inc., New York
Prudential Insurance Company, New York
Owens Corning, Toledo, Ohio
RepublicBank, Houston
RSM Co., Cincinnati
Seattle Art Museum
Seattle City Light 1% for Art Portable Works Collection
Washington Jockey Club, Renton, Washington

AWARDS AND COMMISSIONS
1984 Sambuca Romana Prize, The New Museum, New York
1980 Mural, Federal Building, Moscow, Idaho
 (See also listings under Exhibitions)

ONE-PERSON EXHIBITIONS
1985 Galerie Redmann, Berlin
 Boise Gallery of Art, Boise, Idaho
1983 Monique Knowlton Gallery, New York (also 1981, 1980)
1981 Glenbow Museum, Calgary, Alberta, Canada
 Manolides Gallery, Seattle (also 1977, 1976)
1980 Spokane Falls Community College Art Gallery, Spokane,
 Washington
1977 Fine Arts Center, Washington State University, Pullman
 (also 1975, 1972, 1967)
1972 University of Colorado, Boulder
1971 Columbia Basin College, Pasco, Washington
1967 Spokane Art Center, Spokane, Washington (also 1962, 1959)
1966 University of Idaho, Moscow
1965 Atrium Gallery, Seattle

1961 Stone Court Gallery, Yakima, Washington (also 1959)
1959 Seattle Art Museum
 Eastern Washington College of Education, Cheney, Washington
 Holy Names College, Spokane, Washington
 Larson Gallery, Yakima Valley Junior College, Yakima, Washington
 (also 1955)
 Otto Seligman Gallery, Seattle
1952 Little Theatre Workshop, San Antonio, Texas
1950 Torrence Associates, Austin, Texas
 Utah State Agricultural College, Logan
 Federated Woman's Club, Austin, Texas

GROUP EXHIBITIONS
1984 Galerie Redmann, Berlin, *5 Amerikanische Künstler.*
 Hodges/Banks Gallery, Seattle, *Little Romances/Little Fictions.*
 Indianapolis Museum of Art, *Painting and Sculpture Today.*
 Sioux City Art Center, Sioux City, Iowa, *Beasties.* (Traveling
 exhibition)
 Seattle Art Museum, *The City as Collector.*
1983 Monique Knowlton Gallery, New York, *New Work.*
 Museum of Contemporary Art, Chicago, *Dogs!* (Traveling exhibition)
 Corcoran Gallery of Art, Washington, D.C., *38th Corcoran
 Biennial Exhibition of American Painting/Second Western States
 Exhibition.* (Traveling exhibition)
 University of North Carolina, Greensboro, North Carolina,
 Art on Paper 1983, 19th Weatherspoon Annual Exhibition.
 American Academy and Institute of Arts and Letters, New York,
 Hassam and Speicher Fund Purchase Exhibition.
1982 Institute for Art and Urban Resources, PS 1, Queens, New York,
 Beast: Animal Imagery in Recent Painting.
 Loch Haven Art Center, Orlando, Florida, *Collector's Choice.*
 Koplin Gallery, Los Angeles, *Four Artists from Pullman,
 Washington.*
1981 Nassau County Museum of Fine Art, Roslyn Harbor, New York,
 Animals in American Art.
 Cleveland Museum of Art, *Contemporary Artists.*
 Jacksonville Art Museum, Jacksonville, Florida, *Currents: The
 New Mannerism.* (Traveling exhibition)
1980 Art Gallery, Sonoma State University, Rohnert Park, California,
 Nine From Pullman.
 Lester Gallery, Inverness, California, *Three Person Exhibit:
 Gaylen Hansen, David Starey and Chuck Wiley.*
 Seattle Art Museum, *Northwest Artists: A Review.*
 University at South Florida, Tampa, Florida, *Phyllis Bramson
 and Gaylen Hansen.*
 Museum of Art, Washington State University, Pullman,
 Faculty Show. (Also 1979, 1978, 1977, 1976, 1974, 1972)
1979 Lester Gallery, Inverness, California, *8 from Pullman.*
 The New Museum, New York, *Sustained Visions.*
 Manolides Gallery, Seattle, *Erotic Art.*
1978 Manolides Gallery, Seattle, *3rd Annual Dog Show.*
1977 Foster/White Gallery, Seattle, *Pullman, Washington 99163.*
 Artists' Workshop, Portland, Oregon.
 Western Gallery, Art Department, Western Washington State
 College, Bellingham, Washington, *Artists from the Other Side.*
1976 Portland Center for the Visual Arts, Portland, Oregon, *In Touch:
 Nature, Ritual and Sensuous Art from the Northwest.*

Cheney Cowles Memorial Museum, Spokane, Washington, *Eccentric Art*. (Traveling exhibition)

1975 Eastern Washington University Gallery, Cheney, Washington, *Artists of the Palouse*.

1973 Olympia, Washington, *Governor's Invitational Art Exhibition*. (Also 1969, 1968, 1966)

1971 Spokane Falls Community College, Spokane, Washington, *WSU Faculty Show*.

1969 The Art Gallery, Arts Hall, Washington State University, Pullman, *Faculty Show*. (Also 1968, 1967, 1966, 1962, 1961, 1959)
Short Gallery, Seattle.
Yakima Public Library, Yakima, Washington, *WSU Faculty Show*.

1966 Wenatchee, Washington, *North Central Washington Annual Art Exhibition*.
Spokane Art Center, Spokane, Washington, *WSU Faculty Exhibition*. (Also 1962, 1961, 1960, 1959)
Eastern Washington State College, Cheney, Washington, *WSU Faculty Exhibition*.
Japan, *Governor's Invitational Traveling Exhibition*.

1965 Rocky Reach Dam, Wenatchee, Washington, *Keith Monaghan et al., WSU*

1964 Seattle Art Museum, *Annual Exhibition of Northwest Artists*. (Also 1962, 1960, 1959, 1958, 1957, 1956)

1963 World's Fair Exhibition, Seattle, *Henry Art Gallery Invitational*.
Cheney Cowles Memorial Museum, Spokane, Washington, *Pacific Northwest 15th Annual Art Exhibition*. (Also 1960, 1959, 1958, 1957, award: 1960, 1959, 1958)

1962 San Francisco Art Institute, *81st Annual Painting Exhibition*.
Nelson-Atkins Museum of Art, Kansas City, Missouri, *Centennial Exhibition of American Association of Land-Grant Colleges and State Universities*.

1961 Cheney Cowles Memorial Museum, Spokane, Washington, *Exodus Compared*.

1960 Otto Seligman Gallery, Seattle, *Gaylen Hansen and Virginia Kobler*.
Skagit Valley Junior College, Mount Vernon, Washington, *WSU Faculty Exhibition*.

Woessner Gallery, Seattle, *Annual Invitational*. (Also 1959, 1958, 1957, 1956; awards: 1960, 1959, 1958)

Seattle Art Museum, *Northwest Watercolor Society Annual*. (Also 1959; award: 1960)

Tacoma Art League Gallery, University of Puget Sound, Tacoma, Washington, *Contrasts in Art*.

Grace Campbell Memorial Museum, Spokane, Washington, *Annual Watercolor Exhibit*. (Also 1958, 1957)

1958 Henry Art Gallery, University of Washington, Seattle, *Artists of Washington*.
Grace Campbell Memorial Museum, Spokane, Washington, *WSU Faculty*.
Southern Oregon College, Ashland, Oregon, *Invitational Exhibition*.

1957 Larson Museum and Gallery, Yakima, Washington, *Artists of Yakima and Vicinity*. (Also 1956, 1955)
Tacoma Art League Gallery, Tacoma, Washington, *17th Annual South and West Art Exhibition*. (Award)
Santa Barbara Museum of Art, Santa Barbara, California, *Second West Coast Biennial Exhibition*.

1955 Charles and Emma Frye Art Museum, Seattle, *West Coast Invitational*.

1954 Fine Arts Gallery of San Diego, *34th National Exhibition of the California Watercolor Society*. (Traveling exhibition)
Los Angeles County Museum of Art, *Artists of Los Angeles and Vicinity*. (Also 1953; award: 1954)

1952 Department of Art, University of Texas, Austin, Texas, *Faculty Exhibit*.

1951 Texas Fine Arts Association, Austin, Texas, *Annual National Exhibition*. (Also 1949, 1948, 1947)
Denver Art Museum, *57th Annual Exhibition for Western Artists*.
Nelson Atkins Museum of Art, Kansas City, Missouri, *Second Mid-America Annual Exhibition*.

1949 Utah State Institute of Fine Arts, Salt Lake City, Utah, *Annual Exhibition*. (Also 1945, 1943; award: 1945)

1944 Utah State Fair, Salt Lake City, Utah. (Award)

BIBLIOGRAPHY

PERIODICALS

Appelo, Tim. "50 Northwest Artists." (review) *Pacific Northwest* (December 1983).

August, Lissa. "Western Artists Strut Their Stuff." *People Weekly* (March 14, 1983): 34 (Illus.).

Berger, Leslie. "Visions of a New West." *Washington Post,* February 2, 1983 (Illus.).

Bierbower, June. "Gaylen Hansen: Small Town WSU Artist Wins 'Big Apple' Acclaim." *WSU Hilltopics,* January 1982.

Campbell, R. M. "Artist Presents the Spectacle of Nature." *Seattle Post-Intelligencer,* May 28, 1981.

Dike, Patricia. "Artist Finds Power in Simplicity." *The Spokesman-Review* [Spokane, Washington], October 12, 1980 (Illus.).

"Federal Building Mural." *Palouse Empire News* [Moscow, Idaho], November 20, 1980. (Illus.).

Flanigan, James C. "Western Artists Evoke Humor, Horror of 'New West'." *Oregonian* [Portland], February 8, 1983.

Fleming, Lee. "The Corcoran Biennial/Second Western States Exhibition." *Art News* (May 1983).

Ffrench-Ffrazier, Nina. "A New York Letter: Gaylen Hansen." *Art International* 24 (September/October 1980): 84-85 (Illus.).

Fudge, Jane. "The Second Western States/38th Corcoran Biennial Exhibition." *Artspace: Southwestern Contemporary Arts Quarterly* (Fall 1983) (Illus.).

Glowen, Ron. "Natural Selection: Gaylen C. Hansen." *Vanguard* 10 (February 1981): 22-27 (Illus.).

Glueck, Grace. "Two Biennials: One Looking East & the Other West." *New York Times,* March 27, 1983.

————. "Childe Hassam's Legacy Continues to Flower." *New York Times,* November 27, 1983.

Hackett, Regina. "Raising a Few Hackles, Amid Show's Pleasures." *Seattle Post-Intelligencer,* June 8, 1980 (Illus.).

Heartney, Eleanor. "Art in Good Company." *TWA Ambassador* (March 1984): 37 (Illus.).

Henry, Gerrit. "Gaylen Hansen at Monique Knowlton." *Art in America* (January 1982): 145 (Illus.).

Holmes, Ann. "The Inside Story." *Houston Chronicle,* December 11, 1983.

Kangas, Matthew. "Little Romances/Little Fictions." *Vanguard* (May 1984).

Klein, Ellen Lee. "Gaylen Hansen." *Arts Magazine* (December 1983): 35-36 (Illus.).

Kindermann, Dieterich. "Don't Mistake Gaylen Hansen's Art for Primitive." *Idaho Statesman* [Boise], May 1985 (Illus.).

Larson, Kay. "Talkin' 'bout My Generation." *The Village Voice,* June 18-24, 1980.

Nordlun, Kathi. "Pick of the Week." *LA Weekly* [Los Angeles], August 13-19, 1982.

Phillips, Deborah C. "Gaylen Hansen." *Art News* 81 (January 1982) (Illus.).

Pincus, Robert L. "Galleries: La Cienega." *Los Angeles Times,* August 20, 1982.

Richard, Paul. "The Range of the West." *Washington Post,* February 2, 1983.

Roth, Richard. "Bright Fables of the Palouse." *Pacific Northwest* (September 1982): 22-28 (Illus.).

Russell, John. "Art: Collective Paradoxes for the Summer Season." *New York Times,* June 20, 1980 (Illus.).

Silverthorne, Jeanne. "Gaylen Hansen." *Artforum* (October 1980) (Illus.).

Smallwood, Lyn. "Little Romances, Little Fictions." *The Weekly* [Seattle], February 8-14, 1984.

Tarzan, Delores. "Show and Counter-Show." *Seattle Times,* July 3, 1980 (Illus.).

————. "Figures Show Fantasy, Process at Seders, Manolides, Matheson." *Seattle Times,* October 5, 1976.

Tousley, Nancy. "Artist's Work Linked to Frontier Tradition of Tall Tales." *Calgary Herald,* February 26, 1981 (Illus.).

Wolff, Theodore F. "Major American Art—N.Y.'s SoHo." *Christian Science Monitor,* October 7, 1981. (Illus.).

————. "The Many Masks of Modern Art." *Christian Science Monitor,* November 10, 1981 (Illus.).

————. "Isn't this a Lovely Little World I've Made?" *Christian Science Monitor,* August 25, 1983.

BOOKS AND EXHIBITION CATALOGUES

Annual Faculty Exhibit. Austin: University of Texas, 1952.

Annual Faculty Exhibition. Pullman: Washington State University, 1968.

Annual Faculty Exhibition. Pullman: Washington State University, 1969.

The Art Collector. Houston: RepublicBank, 1983.

Artists of Los Angeles and Vicinity. Los Angeles: Los Angeles County Museum, 1954.

Fine Arts Faculty 1977-1978. Pullman: Washington State University, 1978.

Ferrulli, Helen. *Painting and Sculpture Today 1984.* Indianapolis: Indianapolis Museum of Art, 1984.

5 Amerikanische Künstler. Berlin: Galerie Redmann, 1984.

Gaylen Hansen. Pullman: Washington State University, 1975.

Guenther, Bruce. *50 Northwest Artists.* San Francisco: Chronicle Books, 1983.

Hinson, Tom E. *Contemporary Artists.* Cleveland: Cleveland Museum of Art, 1981.

Lippard, Lucy. *In Touch: Nature, Ritual and Sensuous Art from the Northwest.* Portland: PCVA, 1976.

List, Clair. *The 38th Corcoran Biennial Exhibition of American Painting/ Second Western States Exhibition.* Washington, D.C.: Corcoran Gallery of Art, 1983.

Mendoza, David. *Pullman, Washington 99163.* Seattle: Foster/White Gallery, 1977.

Preble, Duane and Sarah. *Artforms.* New York: Harper and Row, 1985.

Ratcliff, Carter. "Introduction" in, *Monique Knowlton Gallery.* New York: Monique Knowlton Gallery, 1981.

Stigliano, Phyllis and Janice Parente. *Animals in American Art 1880's-1980's.* Roslyn Harbor, New York: Nassau County Museum of Fine Art, 1981.

Thomas, Kathleen. "Gaylen C. Hansen" in, *Sustained Visions.* New York: The New Museum, 1979.

White, Peter. *Gaylen C. Hansen.* Calgary, Alberta: Glenbow Museum, 1981.

EXHIBITION PREPARATION

Patricia Grieve Watkinson, Curator and Director
Bruce Guenther, Guest Curator
Museum Staff: Suzanne LeBlanc, Curatorial Assistant; Margaret Johnson,
 Secretary; Pamela Lee, Registrar; Michael Sletten, Security Manager.

PHOTO CREDITS

Charles Adler (Catalogue 16)
Marsha Burns (portrait of Gaylen Hansen)
Paul Boyer (Catalogue 5)
James Carroll (Catalogue 3, 4, 7)
Michael Cordell (Catalogue 36)
D. James Dee (Catalogue 21)
Chris Eden (Catalogue 11)
Cliff Edgington (Catalogue 10)
Roger Gass (Catalogue 23)
L. C. Llewellyn (Catalogue 13)
Ron Marsh (Catalogue 9)
Jerry J. McCollum (Catalogue 1, 2, 8, 12, 15, 17,
20, 25, 27, 28, 29, 30, 31, 32, 33, 34)

PUBLICATION PREPARATION

Designer: Christine Mercer, Washington State University Press
Editors: Fred Bohm, J. D. Britton, and Patricia Grieve Watkinson
Typeset by: Office of University Publications and Printing, Washington
 State University
Printed by: Thomson-Shore, Inc., Dexter, Michigan